Love-Based Mission

HOW TO CREATE A BUSINESS THAT SERVES YOUR SOUL

by Therese Skelly

D1599177

Love-Based Mission:
How to Create a Business That Serves Your Soul.

This book may be purchased for educational, business, or sales promotional use. For information, please email info@lovebasedpublishing.com.

ISBN 978-1-945363-13-9

Library of Congress Control Number: 2020905440

Contents

Love-Based Mission

How to Create a Business That Serves Your Soul

Dedication

This book has been the journey of my whole life. The joys, the challenges, the lessons, and always... that beautiful mission that continuously guides me and never lets me go. It's a joy to share this work with you. And along the way, there are people who have made it possible, so let me thank them now.

To my amazing clients. You trusted me. You opened your heart. You took risks. You said "yes" to your mission. I'm beyond grateful to have been on the journey with you.

To my dear friend Lizabeth Phelps who was the midwife for getting all this material out of me in an organized fashion. I could not have done this without you!

To the wonderful women in my life who hold me, challenge me, fiercely love me, and always call out the best in me. You have been my lifeline, and I get to do the work I do because of the support you give. Thank you, Julie, Nancy, Michele, Nathalie, Kris, Jana, Lizabeth, Sonia, Renee, MaryPat, and Peggy.

To "the lads," Danny and John. It has been my deepest joy and gift to be your mom. I love you both more than you'll ever know. We are closer than ever, and I'm blessed because of it.

To my beloved. Our relationship fuels me. Thanks for the joy, late night karaoke sessions, motorcycle rides and martinis, fun, play, and the delight that you bring. I love what we have created!

1

Love-Based Mission:

Note From The Publisher

This book is part of an entrepreneurial mission to inspire as many people as possible to shift form living a fear-based life to living a love-based life: that is, living and making decisions from a place of love-based emotions like abundance, hope, gratitude, peace, and trust rather than from a place of fear-based emotions like scarcity, fear, shame, guilt, and anger.

Michele PW, author of the first Love-Based Business Books (*Love-Based Copywriting Method: The Philosophy Behind Writing Copy that Attracts, Inspires and Invites; Love-Based Copywriting System: A Step-by-Step Process to Master Writing Copy That Attracts, Inspires and Invites; Love-Based Online Marketing: Campaigns to Grow a Business You Love & that Loves You Back; Love-Based Money & Mindset: Make the Money You Desire Without Selling Your Soul; Love-Based Goals: Your Guide to Living Your Purpose & Passion*) and founder of the Love-Based Copywriting Company, established the Love-Based Copy Philosophy when she first saw the title of a book her friend Susan Liddy wrote, "Love-Based Marketing." (Michele immediately thought of "Love-Based Copy," and then asked herself what the opposite of Love-Based Copy would be, which is fear-based … and then, the entire philosophy downloaded into her.) She now considers herself its steward as it grows, flowing from business topics into other areas of life, including health, relationships, creativity, and career.

As the deliverers of the Love-Based Philosophy message, we believe it's our role to educate people on living a love-based life—and, in the case of this book, building a love-based business.

A lot of what we consider "traditional business" is built on a foundation of fear. But you don't have to build your business that way—in fact, this book is all about building a business that aligns with who you are, at your very core—and doing so from a place of love.

Now, just to be clear, being love-based doesn't mean you don't feel fear-based emotions. On the contrary, people who have embraced love-based businesses and lives in fact DO fully feel all emotions, whether love-based or fear-based. There IS definitely a place for fear-based emotions in our human existence (believe it or not, those feelings exist to help you), so rather than fight them, the idea is to really feel them, and let them move through you.

Being love-based simply means you embody love-based emotions, in your life and in your business.

As this particular book focuses on business, and the following tenets of living a love-based life are important to understand:

- 💜 Love and honor yourself, and create your life and your business around loving and honoring yourself.

- 💜 Love what you do in the world.

- 💜 Receive the money, abundance, prosperity, and gifts that are your birthright.

♥ Realize that just because you love what you do in the world doesn't mean that you love every aspect of everything you do each day. Part of living a love-based life (and building a love-based business) means being open to the complete experience of living. Sometimes it means making hard choices.

You have a choice about the way you build your business.

By investing in this book, you've made the choice to learn about whether you can join us on the love-based path, and shift into a love-based way of living (and working) … one that perfectly matches who you are, when you're at your very best.

Welcome, and happy reading! We look forward to walking alongside you.

6

Preface

I'll never forget the day I saw the ad.

It was 2004, I was a brand-new life coach, and it read, "Business Coaches Wanted."

Now, on paper, I was underqualified. Really, I NEVER, EVER should have even responded to it. Heck, I'd been a psychotherapist for years, with a master's degree in counseling and an undergrad in criminal justice. I'd worked in a drug treatment center, a prison, a psychiatric hospital, and with all kinds of fighting couples and folks assuming their parents had messed them up.

My MIND told me that applying for this job was a freaking CRAZY decision! It was a very reputable coaching company, and I had ZERO experience. I'd never even read a business book! I had no idea what Excel was (besides a phone company way back in the day). The only business I'd ever worked for was an insurance company as a receptionist when I was 18, and I pretty much sucked at that job.

So why in the world would I think that business coaching could be a great potential career path? (If any wise human would have vetted me then, he or she would have said, "Oh, hell no, sister.")

Yet there was something else at play ... something else happening inside of me ... and it all came down to one word:

Soul.

My soul was ready for transformation. It knew exactly the trajectory I was to follow, which is why my hands immediately flew to the keyboard to fill out the application. (Looking back, I'm SO thankful that my mind—and all my inner gremlins—didn't succeed in holding me back by telling me how wrong I was, and how I would surely fail.)

I submitted the application, had an interview with the director of coaching, and the very next day, I was officially a business coach.

Holy. Shit! Now what?! Again, my experience and skills were around working with inmates, addicts, and wounded people, helping them uncover *where* they were broken, and how to find the path out. But growing a business? Making money? Marketing? Sales? Good lord ... what had I gotten myself into??

Despite all the doubts that could have held me back (even after I had the job), that single decision changed the trajectory of my life.

Seeing that ad got me in tune with my soul's calling, so I could be in service to that calling. It was almost as if, up until that point, I had been leading my life blindly.

Suddenly, I was inspired to follow this new energy/prompting in a way I never had before.

The bottom line: saying "yes" to something that seemed completely crazy on paper was the very thing that led me to my soul purpose work, and the woman I am today.

Was it easy? Oh, hell no. Not professionally OR personally.

A couple years after becoming a business coach, my husband decided that he no longer liked the person I was becoming.

At first, it was absolutely devastating. I had found my new tribe of fellow entrepreneurs—people with big visions like mine—and I WAS changing. As a result, the husband and I were drifting apart. If I'm being really honest here, I'm pretty sure I even sabotaged a lot of my early success because I had a *knowing* that, if I kept growing, I would probably lose my marriage.

So, I would stop and start, and stop and start again, and I surely dimmed my own light tremendously as I tried to save my family. This pattern of trying to rescue my relationship, be there for the kids, and not factor in my own happiness was deeply ingrained in me.

Finally, in 2005, he asked for a divorce. (At the time, I didn't have the courage or the belief in myself to have made that decision for us.)

That wasn't the only relationship that changed as I did. In fact, many of my friendships shifted and I connected with a different group of people.

In all honesty, I wasn't entirely confident about all the changes. There were many nights when I would lie awake questioning whether I was being a good enough mother, because so much of my time and attention was focused on learning how to grow a business.

9

Not only that, but to my horror, in 2010 I endured a bankruptcy, the loss of my home, and tremendous internal pain in service of keeping my vision alive when the recession hit. It was the most difficult time of my life.

But there was still that "thing" inside me that *knew* I couldn't give up and just get a j-o-b. THIS was my soul's path, and I was determined to do whatever it took to fulfill it.

When my husband left me, I had no idea that I could make enough money to support myself, let alone be a good mom to my kids. And yet here I am years later, proud of the six-figure business I have built myself! I was able to model for my two sons what a determined and driven woman can do, as well as showing them how, eventually, two parents can come out on the other side of a divorce as true friends who work together to raise their children.

And today, I am completely on my soul's path!

It took surrendering to get here … to becoming who I really am. On the path, I had to let go of so much of my old life. I had to overcome the limiting thoughts and dysfunctional patterns that held me back, before I could reach my true destination.

Which brings me here, to this page.

Consider this:

What if the decision you're facing right now—to be a love-based business owner—was, by design, the very thing that would ultimately lead you to be even more deeply connected to the best version of you?

To your purpose?

To your Higher Self or Higher Power?

What if you didn't have to sit for 500 hours on a meditation cushion to have an epiphany, or spend boatloads of money on a therapist trying to unlock the reasons you, like all of us from time to time, wonder if you are a bit of a fraud?

Becoming the most magnificent version of you and being the greatest contribution you can be to this world, is a journey.

Now, here's my contention:

Running a business is the very best way to fast-track your personal growth. In fact, I'll even go out on a limb here to say that the entrepreneurial journey is indeed a *spiritual* path.

And, becoming a loved-based business owner WILL change your life! It's that simple.

Here's the thing:

God/Life/Spirit gave you a vision. (Feel free, by the way, to substitute any word that works for you here. If you resonate with God, cool. If not, call it whatever word that holds meaning for you in this context. You'll notice that, in this book, I use the terms "God," "Spirit," "Life," "Universe," and "Divine" interchangeably. When reading, please translate those words for yourself, into whatever you consider the "It" of consciousness/energy that we are all connected to. Please, leave behind any old notions of religion, shame, or guilt that don't serve you. Are we good with that?)

There is something specific that you and you alone are here to do for the world. It's your soul's purpose for your life. You were given the seeds—your unique way to serve-- even if in the beginning you didn't recognize them.

This is the path to your distinct contribution.

Now, it's up to you to become the steward of that work!

As an entrepreneur, you will of course learn how to build a business, and sell or market your services. But you also have to do the *real* work—you *must* uncover what holds you back and discover who you must be to birth your mission-driven business.

Again, your business is absolutely the best vehicle for your transformation, because it allows you to *step up and get your work out into the world.*

But YOU are the one on the line. YOU are up for sale. It's YOUR success ... and YOUR failure.

No doubt, it takes a very special and courageous person to be an entrepreneur.

And yes, you will sometimes experience the highest of highs when you have very successful moments. But other times, entrepreneurship will kick your butt! (Trust me ... nothing will make you drop to your knees faster than not having new clients show up when you *really* need to pay those bills!)

It's the perfect paradox. You get to lean into your fears and learn how to stay focused and strong in the face of doubt. You discover how to be unstoppable when you are not even sure you can keep going on.

This sweet thing known as "business and entrepreneurship" will humble you, define you, transform you, frustrate you, elevate you, and ultimately deliver you.

In this book, I'll show you how becoming a love-based business owner can also be the process by which you reach the personal and spiritual transformation you seek, IF you surrender to it.

What do I mean by "surrender," exactly?

You have to say "yes" to whatever it is that wants to emerge from inside of you, as you, and through you. If it's what you want, you can choose to do it the hard way—kicking and screaming, fighting and clawing the whole way—or you can choose the easier way, by trusting and surrendering. It's totally up to you.

When you trust and surrender, you can basically expect business growth on steroids. But it's an inside-out process—you work on yourself, and your business grows. Stop doing the self-growth stuff, business stalls.

I can promise you that HOW you show up in your business—how you are BEING—will be mirrored back to you in your business … a perfect hologram.

Imagine this, though: Not only is it possible to learn to love your business, but even more importantly, you can learn to love *yourself* in an even deeper way. (My clients come to me ostensibly to grow their businesses but are always so delighted that a by-product of that growth is an increase in their confidence and sense of self, simultaneously.)

My hope is that, in reading this book, you will find peace, comfort, and meaning in the often-challenging times in your business.

I'll share with you the very patterns that are causing you to have a less-than-fulfilling experience as a business owner, because I know from experience that without an understanding of the process, it's easy to feel like a victim. It's easy to become overwhelmed and

frustrated. Hopeless, even, as you deem yourself only cut out to sell shoes or serve coffee (at least, that's where *my* head would go when things weren't working in my business).

All of this is of course exacerbated by modern technology. You look around and compare yourself (and your business, and your life) to everyone else's "look-so-good" circumstances. (You know what I mean here … everybody and their mama on Facebook seem to have "the Midas touch," while you are busting ass and not getting results!)

This book will help you gain perspective, and stay in the moment, as you develop a new understanding of how everything *is* happening in exactly the right time, *for you*.

It's also your guide to leveraging your role as an entrepreneur to access your next level of personal growth.

This book is for you if:

√ You seek transformation—not just in your business, but personally and spiritually, too.

√ You are committed and determined to be your best and are willing to follow your OWN path instead of listening to what everyone else says you should do. (Oh, how I love those traits in my tribe!)

√ You are mighty courageous! (The entrepreneurial journey is not for the faint of heart.)

√ The products or set of services you offer are from your heart—as in, you feel BORN to do the work you do! (In other words, you are *not* trying to sell "schlock.")

√ It's important to you that your business does good in the world. You know, at least on some level, that you MUST do the work you're doing, and that work is your mission in life.

√ You are ready to live and work with more love and less fear.

√ Perhaps most importantly, you are open. You're curious, and willing to dive deep in order to discover how to be an even better version of yourself.

I'm sharing this work because being a love-based business owner means seeing your business for what it *really* is, which is so much more than just a means to an end, or a cash machine.

That's why, when my friend and colleague Michele PW, Love-Based Copywriting Specialist and author of the Love-Based Copywriting books, approached me to write this book as part of her Love-Based Business Series, I jumped at the chance!

And, to further guide you on the journey to becoming a love-based business owner, I've included several exercises and resources

throughout this book. As you read, you can access all of them via my Resource Center, here: ThereseSkelly.com/missionbookresources.

Chapter 1
THE LOVE-BASED PHILOSOPHY

I wholeheartedly believe in the love-based business philosophy:

When you love what you're doing, your customers love doing business with you (and keep coming back for more). Your team and partners love working with you. It's easier to sell a product or service you love.

And perhaps best of all, your business supports a life you love.

So, what does being a "mission-driven, love-based business owner" really mean?

I thought I'd do a bit of research around what generally comes to mind for people when they hear terms like "conscious business owner," or "heart-centered entrepreneur." So, I posted those questions on Facebook.

And wowza, the responses I got were quite surprising!

It turns out that the connotation of being "heart-centered" is pretty negative!

My FB friends had the sense that, if you are heart centered, you are:

♥ Too "woo woo."

- ❤ Not interested in practical things.

- ❤ Missing your left brain.

- ❤ Scared to do the real work.

- ❤ Not grounded.

- ❤ Afraid of charging and earning money.

- ❤ Chasing ideas that are unsustainable and unmarketable.

- ❤ Following shiny objects.

- ❤ Magical thinkers.

- ❤ Dreamers who can't implement.

If all this were true, who in the world would want to be heart centered?!

Yet, for all the less-than-positive connotations those words carry because of an overly saturated market of people who have used and manipulated the meaning, what I know heart-centered biz owners bring to the table is a focus on caring deeply about others as well as the planet. They desire for all things to be whole and want others to feel empowered and loved. They do not put profits over people, and that's quite admirable.

I know that "conscious business owner," or "heart-centered entrepreneur," refers to a shift from the old "me first" way of doing business to one that uses a person's skills and service to do good.

It's a shift toward creating more win-win partnerships ... a movement toward connecting to the whole and contributing to making this world a better place.

This definition of "heart-centered" is in direct alignment with one's soul's purpose. But sadly, the marketing and coaching industry seems to have bastardized some of these concepts.

My belief is that the mind and heart are subordinate to our soul's knowing and to our intuition. The soul provides the ideas or purpose, and then the mind and body work to bring it to fruition.

Getting in alignment with this concept is key. I'll share more about how to do that in upcoming chapters, but for now, let's take a moment to picture what it really is that I'm inviting you to step into.

A love-based business owner is wise. She uses discernment, and while she can lead with her heart, she is also very practical and has a strong sense of self. She is deeply grounded in a personal code that she honors. This leads to a solid set of behaviors, positive habits, and the ability to get stuff done and work implemented. Far from being "airy-fairy," she knows how to make very solid decisions for herself and her business.

Because of her deep understanding of her soul-based mission, she knows that following her purpose creates behaviors that allow her to succeed.

I love the way a couple of my Facebook friends pinned this down in more grounded terms:

To me, a conscious (love-based) business-owner is somebody who is in alignment of mind, body, and soul. He/she merges logic with emotion, and follows it with the aligned action steps. Judy Graybill

I think I'd call it "practical yet spiritually in tune" or "where passion meets practicality."
Alecia Bernardo

What I want you to see is that the "old" definition of the heart-centered business owner smacked of codependent, selfless, not-so-positive patterns (which I will share more about later).

But the new way of looking at this "conscious" or "mission-driven" or "love-based" business owner is quite positive. It blends the best of showing up with a heart to serve, a mission to lead and make a difference, and grounded and practical business practices.

It's about letting love make the decisions, and learning how to find where fear is encroaching, so you don't let fear drive you.

Sounds pretty awesome, right?

(You can read all about Michele's love-based philosophy in her book, **Love-Based Copywriting Method: The Philosophy Behind Writing Copy That Attracts, Inspires and Invites,** here: https://lovebasedpublishing.com/love-based-series/love-based-copywriting-method/)

Chapter 2
YOUR LOVE-BASED BUSINESS

Maybe right now, you're thinking …

"Ok, Therese. I understand what you mean by 'love-based business owner.' But how does being love-based show up in business?"

Great question, my dear reader!

It all begins with our beliefs.

I remember a few years ago, my then 16-year-old son John watched The Wolf of Wall Street, which portrays the worst of the greedy businessman archetype. Well, it left an imprint on my son about how to "be" in business.

He told me he'd have to be ruthless and learn to step over people to get what he wanted. Now, trust me, I have had many conversations with John about how to treat people and how the Hollywood version is not really how you want to live! Trying to teach a testosterone-infused young man the difference between collaboration and competition didn't quite land so well back then, but thankfully, he's now past that age and stage, and sees what true leadership really looks like.

Similarly, I have found that many people coming from corporate America still feel hostage to the 9-5 model of business. They feel guilty if they would prefer to work 12pm-5pm (or even 2am-8am!).

25

This is why, when you're first building your business, it's often necessary to "take the corporate out of the girl" and figure out your natural rhythms.

I know when I first started my business, I believed if I didn't show up in a black suit, I'd lack credibility. That may work for bankers, but it felt like a monkey suit to me! It was completely inauthentic, but I thought it was required to avoid falling victim to that proscribed business owner "dress code." Today, when I see my old banner photo, I can't believe I ever thought it was a good choice. But again, most people starting their own business will look to their vision of "the professional" and replicate what they see. (The trick, you know, is to find your own vibe. Want to work in yoga pants or stay in your pjs all day? Totally your prerogative!)

A few more ways this old belief paradigm shows up … see if you have any of them lingering:

- You believe you have to do everything yourself.

- You have to at least learn everything yourself, so if you do outsource it, you can supervise.

- You have to put your clients first, and work whenever they want you to.

- If you take better care of yourself, it would somehow be greedy.

Now, imagine moving away from the old paradigm, into the new love-based way of being. More conscious. More mission driven.

THIS is the new paradigm that will lead you to having a business that serves your life as you serve others!

Remember, your business is the very vehicle your soul has chosen to express itself.

And that, my friend, means you're in for one magical (and sometimes crazy!) biz-building journey!

It's not always easy, but it can be richly rewarding when you understand that growing a business really is more about growing *yourself*.

Chapter 3
WHAT *REALLY* GETS IN THE WAY OF YOUR BIZ-BUILDING SUCCESS?

Since you're reading this, my guess is that you identify with being helpful, loving, giving, and of service to others.

That's why you went into business in the first place, right? Because you knew you could make a difference in people's lives.

In fact, you're likely the first one your friends come to when there is a problem, because they know you will always be there for them.

Truth is, very often in our culture, these are the qualities expected of women. Maybe you learned by your mother's example, or your grandmother's (or both!), and are proud of those characteristics in yourself.

This is the 'you' you know yourself to be.

You might even say that your very identity is built on those traits— on the idea of being a "helper" to others. I know it was that way for me. (Heck … I even developed my career as a psychotherapist on it!)

And there is no question that being giving and loving is noble. After all, those are the things that make the world go around, enabling the human race to move forward. Right?

Here's the problem:

Oftentimes, it's these exact qualities that end up working against us when we try to grow a business and get paid well for our work.

It's really a slippery slope, particularly in a service-based business!

Consider the following, and whether they sound familiar:

- 💜 If I'm wired to serve to give—how can I possibly ask for compensation?

- 💜 If I'm selling a spiritual or transformational service, how can I raise my rates?

- 💜 If it's better to give than receive, how can I put a dollar amount on the worth of my giving?

- 💜 How do I market myself to get the visibility I need to grow my business, when for eons, women have been taught to be selfless in our giving?

If you have thought any of these things that have been woven into the very fabric of our upbringing, you probably struggle with *how* to give and love and serve … and CHARGE for it.

Now, you of course don't wake up in the morning with these kinds of thoughts top of mind. But, deep in your unconscious, they linger. **They hold you back and end up creating distractions**

or sabotaging patterns that slow you down and delay your growth.

And because of those internal battles, it's usually safer and easier to default to the areas in our life where we *don't* have to wrestle with the places where we bump into this particular internal conflict.

Think of it this way:

If you have the identity of a person who is "heart-centered" and cares deeply about others but, in your business, you feel awkward and struggle a bit in selling what you do, can you see how it would be very seductive to stay small? Maybe even barter, or charge very little for your services?

Can you see how easy it would be to give more of your time, energy, and attention to the "comfortable" areas of your life? The places where you naturally get approval, validation, and "warm fuzzies" for being loving and heart-centered? (In other words, you focus on your family, children, parents, siblings, etc., who give you all kinds of accolades because of the way you help and give.)

It's *so much easier* to do that than it is to break the norm of the good and loving woman by asking for money, being "too big for your britches" (my beloved Irish grandma always told us not to "be putting on airs"… that literally meant to make sure we didn't behave as if we are any "better"—better dressed or educated, or wealthier—than anyone else), and/or facing rejection in the marketplace.

31

I'm going to ask you to get really, really, honest with yourself, right now.

Up until this point, have you only been comfortable playing small?

Are you stuck in that space because it's just easier to keep giving and serving and helping those you already know than it is to endeavor to serve the greater numbers that your business asks of you?

Are you afraid of being seen as somehow "bad," "unkind," or "ungrateful" if you grow and have to leave some things behind?

If any of this is a "yes" for you right now, I'm willing to bet you (unconsciously) sabotage or slow down your business growth by doing busy work, taking online classes, spending hours researching … whatever it is that enables you to avoid promoting yourself and asking to be paid well for the value you give.

I did it for years. And sadly, I probably used my kids and life situations as a distraction, as well. No shame … just truth.

What to DO About It?

Let's say you've been in business for several years already. You're going through the highs and lows, dealing with waxing and waning success and income levels. You're experienced enough to recognize the patterns you are bringing into your business, and it might be a wee bit discouraging. You've probably done the old "stop-start" thing more than you care to admit. And, despite wanting to be

bigger or raise your rates, you get pulled back, often staying at the same fee level or working with the same kinds of clients.

You may find yourself "throwing spaghetti against the wall to see what sticks," since you no longer know *what* to do to get different results.

You may feel totally burned out, wishing you could change course in your business.

If you're anything like me and most of my clients, you're showing up and doing the work, but you don't love it any longer. You might even feel as if you're simply treading water, desperately trying to keep from going under.

You're ready for change, but you might not know what to do first to create it (especially if you're not even totally clear on what the problem actually is!).

And most likely, you're blaming yourself for what you perceive as a "failure," and looking for solutions in all the wrong places. (Buying info products and madly devouring them, hoping to get that one little silver bullet that will save you? Falling for the "latest and greatest" lead-generating activity that will surely bring in a whole slew of hot prospects? Or, worse yet, … falling prey to a very convincing marketer who you just know will save you?)

If you've "been there, done that," or are doing it now, chances are high that you'll end up wasting a ton of money, feeling guilty,

having your confidence dashed and hopes deflated, and in the end, with a business you *still* don't love.

If you see yourself in this pattern, right now, know that you are not alone.

The problem persists because you are evading the core issue.

I guarantee you this:

You will not build the business of your dreams by investing in all those "solutions" listed above. It won't happen the minute you hire a well-meaning guru to give you his "90-day fast-path-to-cash formula."

Why?

Because the obstacle you're facing is an internal conflict between serving others and serving yourself.

And those obstacles are rooted in your childhood, which I'll dive into more later.

Know this:

Your soul has created this conflict FOR you.

It's the "old" you versus the you who has yet to form as a love-based business owner.

This is your Higher Self calling you forward while your scared self wants to stay the same, because ultimately, that feels safer.

I'm going to say something here that may feel controversial but stick with me.

The truth is that you are a "minister."

Now, don't get tripped up on the word. I'm not using it in a religious context. But if you use the term as a VERB, it is the act of tending to, taking care of, looking after, or assisting.

You minister to those around you. Your family and loved ones. Your community and people you care about.

This is who you are.

And whether you realize it or not, your work has been an extension of that ministry, which means your work is naturally your ministry now.

Granted, some of this (in moderation) is good!

Here's the catch, though:

Your business is not a measurement of your value.

Your clients won't meet your need for love and approval in a sustainable way. You can't expect them to act like your family and loved ones.

I only know this because I did it in the beginning, too. I can quite honestly say that 90% of my actions were coming from a place of needing to prove myself. And when you are looking for approval, it's usually because you *need* to be loved and prove yourself worthy.

The problem: that need creates so many issues that you end up kind of sucking as a business owner! And when that happens, you can't charge a fair rate for your services. Can you relate?

If you can, don't worry. I understand where you are right now, and my goal with this book is to guide you down the path of the love-based entrepreneur ... starting with your mindset.

(Curious if you're being influenced by "proving" energy? You might be surprised at how tricky it actually is and where it shows up. Checkout the Resource page at the end of this book to access my **"How Much Are You Being Influenced by the Need to Prove Yourself? Checklist."**)

I'm going to ask you to shift the way you think about your ministry.

Your ministry *is* your destiny. It simply needs to be *reconfigured*, so that you genuinely, enthusiastically, and freely give to a bigger audience ... sharing your best self with those beyond your normal circles.

Why?

Because you are being called to something greater, and you know it!

You haven't stepped up to play the bigger game your soul came here to play yet. You are loving everyone around you more than you are loving yourself, and you've likely been establishing this pattern for years.

Essentially, you are putting limits around your heart. You're not sharing your gifts on the level you could be, which means you're not reaching as many people as you could be.

To move into that "something greater," you are required to move out of the small space you have been in. And to do that, you have to learn how to identify and shift the patterns that seduce you into pulling back and staying "safe."

That process also means merging your natural, heart-centered state of being with a new focus on your mission so that the mission drives you forward instead of being "misused" in an effort to fill a need, fix a wound, or validate one of your old identities or caretaking roles or co-dependencies.

In other words, you have to address the patterns of needing your business to validate you—and create a whole new way of *being* in your business, if you really want to flourish.

This of course is not going to happen with the snap of a finger, but in these pages, you will find a pathway to "being" the true essence of a love-based entrepreneur—one who still gives and helps and tends, but who also understands and is comfortable with the value of her service, so she can be compensated well for it.

Personally, I have always self-identified as a sensitive, compassionate person with a huge heart and desire to serve. As a result, my friends have always come to me to solve their problems and feel better. I value people over things and am super aware of others' emotions and states of being (that's why I got the master's degree in counseling and worked for years as a psychotherapist).

In that role, I spent way too much time focused on others, outside of myself, as that was the only ME that I knew myself to be.

Case in point:

It's 1986. My father is dying from a very painful year-long struggle with cancer. My best friend Lisa comes to my door and says to me, "Look … your dad is dying. Don't you think you should talk about it?" My response: "No, I'm fine, but how are **you** doing with his death? Are you okay? Anything you want to share about it?"

A perfect example of how accustomed I had become to shifting the focus from myself to others.

Now, focusing on others is a beautiful ability and characteristic in someone, right?

I can tell you firsthand that it's a beautiful, sharp, double-edged sword.

Because when it's out of balance, it's called "codependency."

And that's exactly why it's important to recognize the shadow side of the heart-centered person, which is incredibly difficult to pull apart from the light side to observe objectively.

This book's intention is to guide you through the process of pulling them apart, so you can analyze where the beautiful qualities separate from the destructive ones … so you can find the delicate balance between caring for your clients and standing firm in your own value.

Warning:

This work isn't easy! *Again, you're up against the collective psyche of a society and culture that says women need to focus on helping others first, religions that teach it's better to give than receive, educational institutions that instill the need to follow directions and not trust your own instincts … and of course, your own upbringing.*

I grew up in a very dysfunctional family. Alcoholism, neglect, and abuse were part of the fabric of my experience. I took on the role of parent as a girl, taking care of my alcoholic mother.

Because no one modeled a healthy sense of valuing my SELF for me, I learned early on that my needs didn't matter. I learned to

get approval and validation from my ability to take care of others. I learned not to ask for much or to expect anything from others. (It's no wonder I went on to become a psychotherapist, right?!)

My Irish heritage taught me that life is hard. My ancestors had a tremendous time of it back in the days of The Famine, and my beloved grandmother was quite sickly. I bought into the script that struggle, sacrifice, and suffering were the norm, totally expected and, actually, somewhat noble.

And being a woman of my generation was rife with messages about putting others first, not owning your power/value, and making sure you were *always* "nice and helpful."

As I grew up and had my own kids, it was therefore easy to keep getting sucked into family drama, or be held hostage to my business, which made me feel guilty for not being with my kids.

All of this made it *extremely* difficult to value my services and charge more! (When I first started working as a therapist, I practiced in a community mental health facility, so would sometimes have a client pay only $10 a session. Try jumping into the coaching world wanting to be successful with that background!)

It took me years before I finally found my stride and hit that magical six-figure mark in business.

I'll say it again:

When you have the heart to serve, but you can't value yourself, it's easy to over-give and under-charge. You may not even be able to articulate why you are the best choice for someone to work with, even when you know you are.

For example, I knew I was amazingly talented, had a huge heart, and was very likely better than most in the industry, but because I was WIRED to be more concerned about taking care of others than I was about taking care of myself, it took me *so long* to build my business to the place it is now—to create a reliable money-making business that allows me the true freedom I desire … without over-giving, over-sacrificing, and undercharging.

I'm writing this book because I want you to learn from my lessons and mistakes, so you don't have to waste years, like I did.

Right now, you might be thinking you don't have any of these kinds of patterns holding you back in your business. Ah, that's the rub: these things lie quietly in your unconscious … you may not even realize they're there! But if you struggle to grow your business—to value yourself in a way that supports you financially—I can almost guarantee you these tricky chains are holding you back.

And the ONLY way to ever succeed in business the way you want is to break them.

You cannot live by the "selfless-and-successful" notion any longer. They cancel one another out.

So, knowing it is most important for you (and for me) to give, serve, and/or make a difference, I want to ask you now to open your arms and embrace a much greater "family" through the ministry of your work.

I invite you to discover how to break down the patterns that have created the impasse that is keeping you stuck, however deeply embedded they are within you, so you can extend your heart, value yourself more, and earn good money.

That is the secret to your success.

This book is a journey into how to BE a love-based entrepreneur. It's also about your business becoming a path to personal growth and transformation … if you let it. It's about using all of your gifts to truly be the best YOU that you can be. It's about your business serving your life instead of the other way around.

So, if you have ever felt tired of playing small, sick of the subtle sabotage that creeps in and dismantles your success … if you're ready to get the exposure, visibility, and satisfaction you desire, keep reading!

Together, we CAN end the doubt, procrastination, and lack of clarity you're experiencing now, and finally figure out what to do to create the best possible business foundation for YOU.

My Approach:

You should know that I use an "inside-out" approach with all of my clients.

Think about how things are created.

Everything starts on the *inside*. Nature moves from the inside out.

So doesn't it make perfect sense, then, that if you want to achieve financial growth, you first need to concentrate on personal growth?

That means you work on YOU first, and then strategize business development steps.

I've had more than one client say, "I thought I was coming to you to save my business, but you really ended up saving me."

Yes. My beautiful reader, let me save you from even one more minute of living a life that is less than what you deserve … from being fear-based versus love-based.

Let me spare you the codependent dance that women often step into when they jump into the business world.

And finally, let me save you from the heartache of feeling like a failure because you couldn't get your beautiful dream out into the world.

Won't you join me on the journey to becoming a love-based business owner?

The first step is to simply decide.

I know. That may seem so very simplistic, but everything starts with a decision. In fact, nothing new can be in place until you decide.

Tony Robbins often asks his students, "Are you interested, or committed? Because if you are interested, you'll do what's convenient. But if you are committed, you'll do whatever it takes."

To me, a strong decision denotes commitment. And this kind of powerful decision never starts with any of the following phrases:

"I hope I can."

"I want to be able to."

"I wish it would happen."

"It would be great if it occurred."

"That might be nice."

Nope. A solid decision is a declaration—an affirmative commitment to yourself to do things differently.

So do you want to? Are you ready to commit right now?

Say it with me:

"Starting today, I decide to move into having a more love-based business."

Boom. Didn't that feel solid?!

(In the Resource section at the end of this book, you'll find a link to an entire page of sample declaration ideas. Check them out, and then create your own that you can print out and begin embedding in your mind!)

Here's the really cool part—in essence, making a decision like that begins to forge the new identity you must shift into. Because while there are specific actions you'll take and practices you'll adopt as a love-based business owner, in the end, it's your identity—your BEING—that is most important.

I'll tell you a story.

Years ago, a relationship I was in ended. For many (crazy) reasons, I could not get over it! We were together for only six months, but 18 months later, I was still pining after this man. No matter what I tried, I could not let go. I was still triggered and sad, so one day during a call with my life coach, he asked, "What would it take to get over this man?" The funny part is that thought had never occurred to me! I was magically waiting for something to happen whereby I stopped feeling the pain of loss. So, when my coach asked that powerful question, I remember sort of surprising myself by saying, "I just need to DECIDE to finally let this go."

What happened after that was remarkable.

When I was tempted to look through our old photos, I'd ask myself, "Would a person who has DECIDED to let go take this action? Ummmm, absolutely not! So, stop it, Therese!"

I'd find myself feeling sad or remembering the good times, and once again, the decision I made began to not only forge a new identity for me, but more importantly, for my behavior. In a matter of a few weeks, I was over him.

All because I decided, and that one decision was the key to freedom that I hadn't been able to find on my own.

Now, a word of caution to all you over-achieving types: once you decide to move to a more love-versus-fear-based way of running your business, please do not attempt to turn around every little thing in a flurry of action to back your commitment.

After you commit to BEING this new way, sit with your intuition, or mentor, or mastermind partner, and figure out the best first place to start.

Maybe it's by being more transparent or real in your marketing. So how about starting by doing one new newsletter article sharing what you've learned and why it matters?

Or, if you're ready to stop the train of fear that runs at Mach speed whenever you try to make a sale or bring in new business, maybe

you create a more supportive "talk track" that you could lean on when things don't seem to work. A couple of my favorites are, "God is my source," and "This isn't happening to me; it's happening for me."

I also love to ask how a particular situation is perfect, because even though it may not look that way in the beginning, if you try to see the bigger picture, you'll often find a hidden blessing in *not* getting what you wanted, or for having to go through whatever is happening.

So, it's decision time. Yes, right now! I want you to decide. Are you ready?

Are you a full-on "YES" to becoming a love-based entrepreneur?

Are you willing to do *whatever it takes* to be the steward of the work you're supposed to do, and do your work in a way that nourishes you, as it contributes to the good of others?

If you're NOT a strong YES, complete the following exercise.

EXERCISE: Getting to Your YES

Ask yourself the following questions and write down your responses.

- What would it take for me to be a 100% "yes" to pursuing the love-based entrepreneurial path, and the journey that goes along with it?

💜 What about that is frightening?

💜 Who am I worried about upsetting or offending?

💜 What change do I fear happening to me?

💜 How will I decide? (What's my process? Do I sit with things? Ask friends?)

If you notice that you have resistance or fear, or aren't sure about the path or next steps, that's totally fine. Remember, you don't have to have the whole journey mapped out for you. You just need to be a "yes" to the decision, and then the next right action will be shown to you.

Next up, I'm going to explain why I believe you're here, reading this right now.

Chapter 4
YOU ARE MADE FOR TRANSFORMATION

Have you ever heard the saying, "Life imitates art"? Well *I* say that life imitates nature.

In fact, I base a lot of my teachings on what I've observed about nature.

Here's what I know:

Nature is always growing. And destroying. And growing. And birthing. And dying.

No matter what state it's in, transformation is constantly occurring, and new life happening.

Now, buckle up, because we're going deep for a minute … like, waaaaaay out there … to talk about the quantum nature of the Universe (stick with me here).

In the "old" days, the widely held belief was that there was an end to the cosmos. Astronomers could use their telescopes to measure distances in space, and the old-school paradigm was that there was indeed a point where space ended.

Then they discovered that the universe is actually expanding! Constantly, in fact—it grows and grows and grows. There is no "end" that they are able to detect.

Now, you and I are made of the very same stuff as the planets and the stars.

So, we're subject to the same universal laws, right?

Consider your body, and its regeneration. Your skin regenerates every two to three weeks. Your liver renews itself every two to three years. And how cool is it that it all occurs without you doing a thing?

Life does what life does. There *is* constant transformation—that's just how it works.

Think of it this way: in autumn, leaves fall off the tree. In winter, the tree goes dormant, appearing lifeless ... but with spring comes new leaves and blooms! It's ALL a rather passive process—and the tree itself doesn't have to do anything to make the process happen.

Sometimes, transformation takes place in a more "fiery" way.

There are trees that only come about as a result of a forest fire. Certain pine trees have seed pods that ONLY open when a fire creates conditions hot enough to break them free. There is no other way for them to be deposited into the ground.

Either way, new growth only happens when the old is leveled ... and that is an integral concept of this book.

And all of this applies to your business, too.

50

At times, entrepreneurial growth and transformation is easy, like the changing seasons, or the skin cells that shed daily from your body, aiding in detoxification. You don't *do* anything to make those things happen.

Then there are those scary, forest-fire types of transformation. *Those* are the times you are asked to do something … to release something that you may not be ready to let go of, or to re-evaluate your priorities. They're more difficult, right?

I assure you, they *are* for your highest good.

All transformation is natural. It's happening FOR you, not TO you.

And this understanding is the "launch pad" for everything else in this book.

Chapter 5
THE ORIGINS OF THE PATTERN

Whenever I introduce myself to a group, I always say, "I used to be a therapist, but don't let that scare you … unless I'm trying to date you. Then you should be very afraid!"

It always gets a good laugh!

Now, I'm about to bring my old therapist hat out to explain why you may be falling into the caretaking/self-sacrificing cycle I talked about earlier.

Obviously, no one in the world wants to be told they have "ISSUES."

But here's the thing: once you have awareness and better understand the origins of the patterns that keep you stuck, you have a choice and a way out. Without that understanding, the reality is that you will continuously flounder as you repeat the same patterns over and over and over. (You've heard that the definition of insanity is doing the same thing over again and expecting different results, right? So yeah … let's go ahead and save you from years of heartache and business angst, shall we?)

Strap on your seatbelt because we're about to dive right into the concept of codependency.

I know … it's a yucky word. And you're probably not feeling overly inspired to embrace it, so bear with me.

This isn't about taking on labels, so don't worry. It IS imperative, though, that you are able to identify with the patterns, behaviors, and dynamics that are causing you to not show up in your business the way you need to in order to reach the level of success you want. (BTW—if you think you are already showing up pretty big already, just wait! Try raising your fees a bunch or, rolling out a new offer that requires you to reveal more of yourself. It will likely bite you in the butt then.)

Let's look now at why it's so difficult for you to charge more, promote like crazy, and step up to the plate as the kick-ass expert you are.

Research shows that, when there is dysfunction of any kind (whether it's severe abuse or addiction, or something seemingly more benign, like neglect) in a family, children develop certain characteristics as coping mechanisms.

One of my clients had a severely disabled sister, and while there was no malice intended, her family ended up operating dysfunctionally. Because my client's sister required so much caretaking, most of her own childhood needs weren't met as her parents focused on their firstborn. As a result, my client came into business displaying many of the characteristics we're talking about here—the need to be perfect, having to prove her worth, over-giving, not being able to ask for her needs to be met, doubting her gifts, and experiencing all kinds of fear, etc.

Things like this that happen during our childhood often leave traces of trauma. For example, divorce, illness, loss of a parent, affairs,

death/grief, etc. Even little micro-traumas like not getting chosen for the sports team, moving, or occasions of being bullied in school can have lasting effects.

So, in response to the traumas, the child develops certain patterns as a way of coping.

Melody Beattie, one of the pioneers of this type of work has a checklist that can help you identify common codependent characteristics.

EXERCISE: Identifying Your Codependent Characteristics

See how many of these you say "yes" to.

- 💜 Do you feel responsible for other people—their feelings, thoughts, actions, choices, wants, needs, well-being, and destiny?

- 💜 Do you feel compelled to help people solve their problems or to take care of their feelings?

- 💜 Do you find it easier to feel and express anger about injustices done to others than injustices done to you?

- 💜 Do you feel safest and most comfortable when you are giving to others?

- 💜 Do you feel insecure and guilty when someone gives to you?

💜 Do you feel empty, bored, and worthless if you don't have someone else to take care of, a problem to solve, or a crisis to deal with?

💜 Are you often unable to stop talking, thinking, and worrying about other people and their problems?

💜 Do you lose interest in your own life when you are in love?

💜 Do you stay in relationships that don't work and tolerate abuse in order to keep people loving you?

💜 Do you leave bad relationships only to form new ones that don't work, either?

Now let's look at some of those items and how they relate to you as business owner.

What if your identity is wired to take care of people?

Here are a few specific ways that creepy little pattern can show up and sabotage your business. (See if you relate to any of the statements below.)

Money: You may keep your fees low and feel okay about it but find it very difficult (or are afraid) to charge more.

You "chase" money by waiting for the clients to pay via invoice instead of requiring payment up front. (I know … you don't want

to be a bother, do you?) You give way too much away for free. You don't spend money on yourself via mentoring or investing in business, because you're not sure you deserve to do that. You enter into barter agreements that are often one-sided and/or don't work out well.

Time: You don't have boundaries around when you will work and when you won't.

I remember the first time I shared that I only see clients three weeks out of the month, so I can take the fourth week off to recharge, or write, or do whatever I want to do.

Initially, I was sooooo uncomfortable, absolutely SURE my clients would be mad at me for not being more available. But to my surprise, everyone told me they were impressed that I could have such a schedule, and they appreciated the good role modeling. But it took a LOT to get there!

This particular pattern—the need to take care of people—has you saying "yes" to things and people when you would rather say "no." Your time doesn't feel like your own, because you are either too scared to change things, or would feel too guilty if you did.

Clients: You have some clients who don't make your heart sing. You have not been able to get super clear on who is a "hell yes" for you and who is a "heck no," so you take on anyone who is willing to pay you. You are afraid to choose the right clients for yourself.

57

Your clients may not be getting the best results, because in some ways, you may not be able to confront, challenge, hold accountable, or ask more of them for fear of hurting them, bothering them, or being seen as something other than their friend.

Work: You may be doing work someone else thinks you should do, or maybe, you're still doing things that you know in your soul you are supposed to release. Your brand and messaging may be flat and boring, or not at all representative of you, because you are too afraid to step up and finally proclaim your freaking amazingness! This fear may be conscious, or possibly unconscious. You want to shift but have no idea why you are still stuck.

Wowza! Combine some (or all) of these, my friend, and you have a recipe for a pretty problematic business foundation.

Again, no judgment from me … because in the past, I have been *the queen* of all this stuff.

My goal here is to illuminate the patterns, so you can clearly see that what you show up with in your business often has its origins *in your history*. Your unmet needs or unhealed traumas can (and *will*) play out in your life—and will most certainly affect your relationship with yourself, your clients, your overall success, and your sanity.

At this point, you might be thinking that this makes some sense … but it's also a "simple fix." Right? Just recognize the patterns and break them! Easy enough.

Well, not so much. Let's take a look now at the "payoffs" of keeping them around, and why it's so easy to get stuck in them even when you know you don't want them.

Chapter 6
WHAT KEEPS THE PATTERNS ALIVE?

Alrighty, Mama T is about to throw some things out there that may "stir the pot" a bit. Stick with me, okay?

Because in order to break free of the patterns holding you back, you have to get super clear on *all* of it.

Let me introduce a few concepts now that may be unfamiliar to you: secondary gain, conflicting intentions, and payoffs.

Simply put, a secondary gain refers to the reward you receive or reason you have for staying stuck or the same. (I'll share more about conflicting intentions and payoffs in a bit.)

Now, you gotta hear this:

I *know* you aren't waking up in the morning wishing for more of the same less-than-great results! You don't decide on Tuesday morning that *this* will be the day you sabotage your sales, right? Oh, hell no!

By spending thousands and thousands of hours working with clients, I can tell you with absolute certainty that these things are almost ALWAYS unconscious. So, the big goal here is to make the unconscious conscious. Remember — when you have awareness, you then have CHOICE.

I can imagine your brain scrambling a bit right now.

"Really? Secondary gain? Pay off? What the heck are you talking about, Therese? Why in the world would there be any positive reason to keep this stuff going?"

You aren't wrong to think that I've maybe gone over the deep end here a bit.

So, let me explain.

Remember earlier, when I talked about how little control you consciously have?

Notice the iceberg on the right. I want you to imagine what you see above the water as the conscious part of your mind.

Research shows that we actually ONLY control about 5-10% of our thoughts. The rest is (shockingly) controlled by what's under the surface — in the unconscious.

To restate, we are being controlled by that which we aren't even *aware* of. Yikes!!

Very often, if you have something lurking in the unconscious, it will override what your conscious mind wants.

Case in point — let's say you are a mom who desires to grow a business, but you have kids at home.

The conscious part of you wants to grow. To get bigger. To make more money. To serve.

But the unconscious part never had a successful mom role model. Therefore, it may be buying into old cultural conditioning that says good women should stay home with their children. Or, it may be reliving a childhood message you received that tells you things just never work out for you.

You start your business. You hire a mentor. You set goals and begin taking action to meet them.

And then it happens—those seemingly "random" things that interfere with goals. Your kids distract you so much, you get nothing done. Or you get sick.

Suddenly, you're derailed. You lose sight of your plans and tip into overwhelm.

That's when the pattern I see SO often occurs.

Stop and start. Stop and start. Stop. And. Start.

Here's the thing:

You have zero idea that your unconscious mind is actually trying to override your big goals! (What?! I know!)

You set the goals and took action toward them. You gained momentum. But your unconscious brain got uncomfortable, because those goals — your desires — are viewed as unsafe. They're a threat to your identity, your loyalty, and your very sense of self … your way of BEING in the world that you have become accustomed to.

Thus, the conflicting intention.

One part of you wants to grow. But the other part fears (unconsciously!) what will happen if you do.

Very often, it's women who find themselves in this particular bind:

"I want to get rich and have a great business, but what if it takes me away from my kids?"

"I really want to make a bunch of money, but there's a part of me that worries that it will change me."

"I want to grow, but what if I get 'bigger,' and my friends reject me?"

Here's the kicker: Whenever there is an issue of safety in the unconscious, IT WILL ALWAYS WIN! (By the way, I'll give you tools

to shift and make this conscious later, but it's important to first identify and understand the process, because if you don't, it can be crazy making.)

Now granted, sometimes conflicting intentions can be conscious. You hear it all the time, right?

"I want to get healthier, but there's a part of me that isn't willing to give up eating potato chips or having wine." (And that may or may not be what I say to myself, verbatim.)

What a huge conflict you have going on when you have intentions that revolve around different things!

You can see that a conflicting intention is almost always unconscious, but let's talk about the idea of a secondary gain.

It's deeply seated, and often lurks in the unconscious as well.

Let me give you an example.

I was working with a woman who kept stalling things in her business. I'd lay out well-crafted strategy and ideas to grow, and she'd make good strides, but somehow always sort of "fell off the wagon" with what she was supposed to be doing. She had zero idea as to *why* she kept doing this, so finally, one day I asked her my "Let's Flip It on Its Head" question.

It went like this. (Oh, and feel free to use this handy tool whenever you get stuck.)

"Now, I know that this is not going to sound logical or rational, so just answer top of mind. What's the POSITIVE thing about NOT getting your business off the ground and making money?"

Through the use of a powerful, "non-logical" question, my client suddenly realized and shared that if she started making money, she'd have the financial freedom to decide to leave her unhappy marriage.

The secondary gain for her NOT making money was that she didn't have to deal with her marital situation. The lack of money was actually creating an inertia that served her and her husband as they remained locked into their old, dysfunctional pattern.

This is what we refer to as a "payoff." She couldn't break the self-sabotaging, not making money pattern she was playing out. The secondary gain of not having the financial means to support herself meant she didn't have to face the difficult decisions in her marriage. That was the "positive gain/payoff" that was present unconsciously.

What I was able to do was to pull it all apart for her. "Here's an idea. Why don't you choose to decide or not decide on your marriage, and let it have no bearing on your business? Because right now, the way you have it wired, you will not give yourself permission to be successful."

By the way, part two of the "Let's Flip It" question is this: *What would the potentially NEGATIVE thing be if you DID get the success (or outcome) you desire?"*

These are great questions to ask to break up the stagnation and unconscious behavior you may be caught up in.

So, do you see now how this whole payoff/secondary gain thing can grind your business to a standstill?

EXERCISE: Observe Yourself

Watch how you show up in your business. Are there times you know you could do better? Maybe you even underperform or self-sabotage? If you do, it's very likely that your old "giver/helper identity" is threatened by the very thing you are trying to get!

Payoffs/secondary gains are common when someone is up-leveling. It's far easier to offer super-low prices or deal with people who you aren't intimidated by than it is to raise your prices and rise to the challenge of your intimidation! Trust me, I get it. The first time I coached a woman who had already made a million dollars, I had to do a boatload of self-talk just to keep from freaking out! I'd never made that kind of money, and to be able to hold the value I brought and be of service to her meant I had to be keenly aware of the little voices in my head that were telling me things to the contrary. I was definitely aware of my two conflicting "selves"—the bad-ass coach who knew I could absolutely be of service to this client, and

the "not good enough" worrier who was triggered by the fear of failing or of being seen as a fraud.

Payoffs happen when the old version of ourselves and the ways in which we got our love and/or approval needs met clash with the newer version of ourselves that may no longer need that same identity.

EXERCISE: Examining Your Business

Now that you have a new perspective on how conflicting intentions and pay-offs can hold you back, or even sabotage you in your business, it's time to take an honest look at the last twelve months of your business. (And get out a piece of paper and pen, too ... you'll want to write these things down.)

Did you always get the results you wanted? If not, write down any areas, places, or instances where you didn't. Get really specific here. Then, dig deep. How might that specific instance have been influenced by a conflicting intention or pay-off?

For example, maybe you find that there was someplace you held back, unconsciously, because a part of you was a little intimidated by moving forward. You dig deeper and realize you were intimidated because even though you wanted to grow your business by going to a two-day networking event, you were also worried how your husband would feel if your business was more successful than his.

Chapter 7
CHOOSING LOVE OVER FEAR

Basically, being a love-based business owner is about choosing love over fear.

Now, we all dance with fear at some point, right?

Think about when you first became a business owner. Fear is the driver of all things, isn't it? Fear of not being enough. Fear of not being able to deliver results or not attracting the right clients. Fear of things not working out or of losing money.

Fear, fear, fear.

And sadly, fear is often used to manipulate. Who among us hasn't been at least seduced into buying (or seriously considering) that program that plays on our deepest fears of not being able to take care of ourselves or our family?

Old school marketing is about finding the fear or pain point, agitating the heck out of it, and then offering your solution as the *only* thing that will work to eliminate that fear or pain. (And let's not forget the sleazy salespeople who tell you if you *don't* buy, then clearly, you don't want it badly enough … which just pushes more fear/shame into the space.)

Ugh. No more!

Here in the love-based business movement, we play by different rules. (You can read more about all of this in Michele PW's other books in her love-based series, here: .)

Let me share with you some very tangible examples of how the love-based concept plays out in business. (And guess what? You may be doing some of these things already but have never really "noticed" that it was different or that you were already one of us!)

Marketing

This is a big one! Just a bit ago, I referenced "old-school" marketing, in which we literally are taught to push the pain and play to the fear.

You can see fear-based marketing at play when you get one of those last-minute, kinda-desperate emails from someone whose launch is clearly not going well.

Let me clarify something right here, though — there absolutely *is* a place for pain in love-based marketing. Your client IS in some sort of pain, so you do have to kind of let folks say to themselves, "OMG, she is talking about what I'm feeling now." So yes, there may be some messaging in your copy where you illuminate where your ideal client is struggling now, or what might happen if things don't change.

What works better?

Gently acknowledging the pain, and then, *asking them what they desire!* Show them that you have a very good understanding of what they are struggling with. Then, encourage them to ask what they would love to have in their life instead of that pain.

This will bring you clients who aren't just looking for you to "save them" from their scary situations. Remember, you also have to trust that the right clients will find you. (Yes, that takes a lot of faith, trust, and surrender! More on this later.)

Selling

Fear-based selling uses manipulative or shaming tactics. It's about doing everything you can to get the sale. Years ago, I had a discovery session with a prospective client. She had no money, and had lost her home to foreclosure, yet a coach had convinced her that she would "save" her. That poor, scared woman racked up $1500 a month on a credit card to work with that coach but got zero results. She was going deeper and deeper in debt as she succumbed to a fear-based sales pitch. This one truly broke my heart.

Being love-based means turning clients away or directing them to another resource if they aren't the best fit for you. It's first trusting that the right people will come to you, and then, that you can have a genuinely helpful conversation enrolling them into investing in your services without ever pushing someone to buy something that is not the right fit.

Growing Your Business

You may be trying to grow your business by doing things that work for the gurus out there, but that you don't love, or that don't resonate with who you are anymore. If this is you, you are fearful that if you don't do it a certain way, it will never work.

That means that instead of tapping into the soul of your business, or following your intuition, you are afraid that if you don't get on the Instagram train, you'll be lost. Or, in spite of hating the idea of doing a podcast, you are terrified of not doing it, because what if there IS only one way to grow your business? After all, "they" say it works, so you have to follow it. Right?

Can you feel how that could sap the life out of you?

Why even go into a business that is YOURS if you have to do things you hate and or don't resonate with?

Now, before we go any further, I'm hearing those gremlins in your head right now, right along with those teachers who tell you that you must be willing to do "whatever it takes" to succeed. Need to scrub some toilets to get ahead? Freaking do it! Want money in the door? Then make those darn cold calls. New in town? Get yourself to as many networking meetings as you possibly can.

Not sure about you, but when I read those and feel the rather harsh, often fear-based energy that goes along with those directives, I just wanna recoil and sit on my TV watching bad reality shows! Why? Because even though there must be willingness to stretch and be

outside our comfort zone, doing the WRONG thing for the WRONG reason will never yield the best results. Period!

The work I do with my folks is to find what they *would* love — what would light them up. Not overly keen on a podcast? How about speaking, or creating workshops? There are things that you are better fit for energetically, and a good mentor will not force you and your business into a paint-by-number formula.

When you shift to the love-based way of doing things, again, you tune into yourself, listen to what lights you up, and connect with your prospective clients, in a way that works for *everyone*.

Soooo much easier and lighter!

Serving Your Clients

When you're fear-based, you keep trying to win your clients over, so you go overboard to please them, often sacrificing yourself for them. You fear that if you are not *everything* to them, if you don't work on *their* schedule, they will leave you. (If this is you, I hate to say it but ... your business can't serve you, this way!)

When you're love-based, you actually love YOU more! You factor into the equation what YOU want and need first, and when you come from that place, your clients will happily work within your boundaries.

For example, I don't work weekends or nights. I don't start super early in the morning, and I take lots of time off to travel. And the truth is that I've never had a client fire me because she couldn't get a 7:00 am appointment! Why? Because I know what works for me. Trust me, you don't want me at 7:00 am, because my brain isn't engaged that early. And I love and honor myself enough to create the work calendar that serves me.

Also, I want to note that when it comes to serving your clients, you are not doing them justice if you are too afraid to speak the truth or share what you see. In this way, you're not being authentic. One of the things my clients appreciate is that I call them on their "stuff." Done purposefully, and always with love and to take a stand for them, it calls them out and holds them responsible. If you can't do this, you really aren't serving them at all. You are, instead, keeping yourself locked in fear, which means you're keeping yourself small. And as we talked about earlier, that could be one of your old ways of coping showing up again.

(Ready to uncover what is living under the fear, and discover what you really love to create? Check out the Resource section at the end of this book for my "Fear Busting and Possibility Creating" tool!)

Chapter 8
SO, WHAT'S HOLDING YOU BACK?

Imagine with me:

You come home one day to a flood in your basement. Standing in a foot of water, you call your brother in a panic. He says, *"What you need to do is to get a new couch for your living room. That way, you won't notice the flooding."*

Seems kinda nuts, right? So, you call your best friend, who says, *"If you get some flowers planted in the yard, no one will notice the funky basement."*

HUH?

Flustered, you call a trusted advisor, who tells you that getting a fresh coat of paint will be THE thing that will finally give your house that "elevated" look you've been after.

Clearly, this is all insane advice!

But here's the parallel: often, what's "broken" or holding us back in biz is what's actually "underground," lurking in our unconscious. Yet we look for fast fixes—like adding social media into our marketing mix, or designing a new website, or making some new info products. And *that's* what I call "the $30,000 mistake." I named it that because I actually once had someone tell me she'd spent that much trying to grow her biz through coaching, a new

website, working with copywriters and branding experts, and hiring high-dollar mentors.

All that just to come to the realization that, because she didn't handle her inner game (aka mindset), she wasn't able to get results from what she'd already invested. She had all the patterns I share with you in these chapters, and they all came together to keep her stuck, despite the boatloads of money she had spent on improving herself.

The bottom line:

You too have hidden blocks and unconscious patterns that will prevent you from growing.

I know. Kinda sucky, but it's part of this journey.

Fact: *90%* of what drives your behavior is unconscious. Think about that! You really only have control over about 10% of your life.

That basically means you get to wake up, choose what you wear, and that's about it. ⊠

Let's dissect this concept a little further.

Back when I was a therapist, we used to say that babies come into the world a blank slate. Their early environment "imprints" them with beliefs. And by the time a child is three years of age, his values and sense of self are pretty much set.

Now, that's great if you had a wonderful early childhood experience, but for those of us who suffered trauma, abuse, or illness, etc., that is not such great news!

I used to believe that teaching … until I started working with energy. That's when I came to understand how much more affects us. I began to see that my clients had "beliefs" that they didn't really believe, but that had been passed on to them from their parents. I saw patterns that were etched into them that seemed to have no relevance or origin in their current life.

That's when it became clear what was *actually* holding my clients back.

Today, I know that our ancestor's DNA plays a part in the early establishment of our values and sense of self, behavior, success, and identity. (As much as I adored my maternal grandma, Delia, I didn't relish discovering that I brought her suffering, illness, and belief that "life is hard" into my own life experience via my DNA. The potato famine messed up many Irish people, including Delia!)

The new science of epigenetics is now discovering that, in addition to physical or genetic traits, life experiences are also passed down, which causes chemical effects on the DNA.

So, let's recap: If 90% of what drives your behavior is unconscious (which means you have all kinds of stuff affecting you *unconsciously*), AND you have to contend with generational trauma in your DNA, AND you have "imprints" established in utero and throughout

your childhood … AND all of these things are felt, carried, and remembered by your body … just imagine the effect it all has on how you show up, the results you get, and your overall quality of life! (More to come, on this.)

What I tell my clients is this:

When you have awareness, you have a choice.

One of the first things you need to be aware of is the fears that hold you back from pursuing the love-based business dream in relation to your passion (which, of course, means you're also holding yourself back, too … and your money!).

Here are the top five fears I see my clients struggle with:

A quick note here: If, as you read through these fears, you realize that some or all apply to you, PLEASE be gentle with yourself. Looking inward is NEVER about shame or blame. It's about awareness. You simply can't change something you don't acknowledge.

1. Fear of not being ready. If you believe you have to know *everything* before you even get started, you probably have this fear. Now, I get it; it makes sense. If you're going to build a house, you can't just grab a plot of land and throw some walls up. You have to sit down with an architect and draw the design. You have to measure for window treatments. You have to know exactly how much carpet you're going to need, etc.

Our whole lives, we're planning and prepping in advance. We operate from our heads. While some planning is obviously necessary, the kind that is debilitating comes from a deep-seated fear of failure, shame, or a sense of not feeling worthy enough to really proclaim your worth and own your value.

But when you operate from Spirit and tune in to energy, information is often sourced from a different place. And this is where it gets kind of scary for folks. Because leading by intuition (which is what I teach) isn't very logical or linear. Sometimes, it can even look kinda crazy!

So, if you are a person who needs to know every single detail of the journey before you take the first step, you will naturally push back here. You will resist.

But if you're still reading, you've committed already. You've said, "Yes!"

So here's what you need to know:

There are things required for this journey: trust, faith, surrender, and love.

Notice I didn't mention planning, organizing, or managing *at all*. Those skills can come into play once you get the information—once you say "yes" to your bigger calling.

And there *will* be something that pulls you, if it hasn't already. For me, it was that one little ad I talked about earlier that invited me to step into business coaching. For you, maybe it will be a book you read that evokes strong emotion in you. Perhaps it will be a person you meet who opens up something new in you.

Trust that there *is* an opening for you to follow.

And remember, I'm *not* advocating for you to run off and quit your day job, sell your car, and immerse yourself in ashram! (Of course, if you want to do that that's cool … but you don't have to.)

I'm just saying that you can start the process without knowing the exact course you'll take.

Imagine you're two months pregnant. Would you start buying books about choosing the best college for your child? No! All you need to know at month two is what your body needs to keep you and your baby nourished and healthy.

While it may seem safer to not take any action until you are totally ready, the truth is, you may never FEEL ready.

So, act first, then amend as needed.

2. Fear of being seen. If you're not sure if this one applies to you, try this: schedule a photo shoot or video day during which your goal is to share how wildly brilliant you are. Bam! This fear will hit you right in the face, if you have it.

The reason this one is so common is because it generally comes from childhood patterns of learning to play it safe, not make waves, fit in, and look to others for answers.

Many of us received childhood or cultural messages about not outshining others, not being seen as "better than," for fear of someone's feelings being hurt. It's been a stumbling block for *so many* of my clients, as I watch them shy away from video … from owning their voice.

But here's the deal: when you become an entrepreneur, you MUST BE A LEADER! You need to be at the forefront with your ideas. Your team will depend on you, and your tribe will only trust you if they can SEE YOU! They need to see your positions, your bold ideas, your goof-ups, and your firm stand on things.

Hiding out and playing it safe can absolutely repel money, I promise you.

3. Fear of looking like a fraud. Several years ago, I decided to host the Breaking Down to Break Free telesummit, where I would "out" my story and share with the world the financial challenges I experienced when I committed EVERYTHING to my entrepreneurial path and went through a bankruptcy. My very first thoughts when I considered the idea: *"What are people going to think? What if I lose credibility? Who would hire a business coach who messed up her money so badly, she lost everything?"* (We so often judge ourselves more harshly than we would ever think to judge another, don't we?)

Here's the thing: the majority of the time, it's far worse in our own heads than it is in the minds of our clients. In fact, once I shared my bankruptcy story, people told me they were actually *more* likely to hire me as a coach *because* of my authenticity. They knew my ability to understand where they were or had been, which built the "know-like-trust" factor.

If you fear looking like a fraud, I've venture to guess that you're carrying someone else's energy/belief (keep reading).

4. Fear of failure. When I work with my clients on their blocks, we start with muscle testing (or I use a pendulum) to identify them. One of the questions I ask is: Whose belief/opinion/energy are you carrying? (And heck yes, we DO carry other people's world views!)

I have had many clients of Asian descent who felt they were held hostage by the cultural narrative that they MUST never fail. If they did, it would disgrace their family. Another example is that firstborn children of immigrants (and some people of color) are often under extra pressure "to be better than, just to be good enough."

If you can recognize the thoughts and beliefs that are not your own, they'll be much easier to eliminate, so they don't wreak havoc on your business success. In this case, the first step is to determine whether the fear of failure really does live in you, or if you are acting from someone else's paradigm about what you need to do or be in order to be worthy or successful.

If you assess that it's indeed yours (lucky you!), you'll likely discover that there was some time in your life when you made the decision that, in order to be loved or accepted, you must be perfect, better than, flawless, etc. I talk a lot about shame in my work and will share more about it in the next chapter, but for now, know that shame comes from trauma in our early upbringing, and it teaches us that we are not equal in worth. So, the concern about being seen as a fraud will keep you on the hamster wheel of over-giving and undercharging.

5. Lack of trust in yourself to manage money. This one often shows up in those of us who have made and lost money, or who have family patterns of poverty and lack. In these cases, it's not easy to trust yourself to take care of your finances.

Some of my colleagues will have an awesome five-figure month, and then struggle to pay bills the following two months. Some bring in high-ticket sales, only to have people ask for refunds within the week.

Take a look at your patterns. Does money stay around you? Or does it fly out of your pockets in seemingly crazy and inexplicable ways? If you suddenly inherited a great deal of cash, would you trust yourself to be a great steward of it? If you didn't just answer, "Yes," I can tell you right now that it's not coming! Money likes to be taken care of, and if you are afraid that you'll blow it, it *will* be elusive.

Now, can you see how these barriers can't possibly be overcome by working on better marketing copy, or tweeting more often? Those activities basically dance around the real issues. As I often say…

"The only way around … is through."

Through the blocks and barriers, and on to the other side, where sweet success and personal fulfillment wait for you!

Take a moment now to acknowledge which of these five fears resonate with you.

Next up, I'm going to talk about how to begin creating the change you seek.

Chapter 9
THE COURAGE TO CHANGE

"Courage is not the absence of fear, but rather the judgment that something else is more important than fear." - Franklin D. Roosevelt

So, let's say your "old" identity *is* tied into helping, serving, loving, giving, getting along, and being seen as a good person.

And you start your business. Now, your worlds collide.

The thing is, the YOU who grows your business into one that serves your needs is *not* the same YOU who takes care of everyone in your family and life!

In fact, if you show up trying to run your business with the same old patterns stuck in your unconscious, oh man are you in for a shock!

Now, truthfully, you aren't going to wake up on Friday and have a sudden epiphany that you have been more than a smidge codependent, trying to get your love and approval needs met via your clients and business (unless you are one of us overly analytic mind processors!).

That's just not how it usually happens.

Nope. Most people only decide to try something new when things break down or are no longer working.

It usually looks something like this:

You wake up and notice you are weary to the bone. Like *soul tired.*

Or, you can't figure out why you just aren't feeling the love anymore.

Hell, you may even be making really good money, and can't even make sense of why in the world you are so burned out.

Or, maybe you're resentful.

After all, you've built the machine … just to realize it's taking more of you than it's giving back.

Showing up for your business is now absolutely draining you.

Initially, you may try external fixes, because again, as we all know, it's far easier to focus on the things outside of yourself than it is to sit down and really assess what your part in all of it is.

So, you outsource, or hire more help.

Or maybe you get a new mentor to "kick your ass" into raising your rates or doing more to drive business your way.

Sometimes, getting more help or a mentor *is* exactly what is needed!

But not if you are in the grip of the "seeking approval/proving/people-pleasing" pattern.

Why? Because you'll then focus on pleasing your mentor! You'll still live in fear. The same pattern you are trapped in with your business and clients will almost certainly transfer over to the person whom you have entrusted to help you find your way.

This can lead to disasters, especially when coaches and marketers try to fit you into their "proven seven-step formula."

I've worked with plenty of clients who chose to hire coaches who focused on all the tactical and strategic pieces of business growth, but who would also shame their clients if they disagreed or were unwilling to go along with them. Not only did those clients NOT get the results they wanted, but sadly, they were made to feel like they were wrong throughout the entire process. And almost always, they felt they had wasted a ton of time and money.

I don't want that for you. That's why it's imperative that you realize if you are in this caretaking pattern.

By now, you might be seeing it in yourself. Maybe you have just started to self-identify. If you aren't sure, circle back to chapter three and read the statements again.

Then, complete my **"How Does Shame Show Up?"** Checklist below, because this stuff *is* tricky and elusive.

Here's how this works:

Rate each of the following questions with a 1, 2, or 3, using the scale below.

- 1 = Never.

- 2 = Sometimes.

- 3 = Always/Very Often.

1. I have a pattern of procrastination.

2. I hold myself back from playing big, even when I really want to.

3. I'm waiting for permission, which is crazy, but I seem to need it.

4. I get overwhelmed and shut down or spin around.

5. I have less confidence than I should have.

6. I don't like to ask for help, because I feel like I'm bothering people.

7. I feel uncomfortable really charging more for my services.

8. I have a fear of failure and/or a fear of success.

9. I don't step up, because I need more ___ before I feel like an expert.

10. I deal with perfectionism, so I drive myself nuts with overworking and overanalyzing.

11. I feel like I have to prove myself, so sometimes, things don't seem like they are good enough.

12. There is a little voice in my head that criticizes me.

13. I feel like a fraud.

14. "If they only knew _____ about me, they wouldn't hire me."

Ok, so *now* can you see some patterns in your "old" identity? (This is some sneaky stuff, isn't it?)

If you can, you may be wondering what's next.

It's time to talk about the "how" of breaking out of it, so you can begin developing the new identity you need to really be the BEST love-based business owner you can be, so you can use all your God-given gifts!

Let me restate this one more time — it's that important:

You *can* get out of your "small space," which includes taking care of those you love and sacrificing yourself, and step into the "bigger space" of helping more people, built on a foundation that serves your life ... not the other way around. You *can* move from living in fear to living in more faith, while developing stronger self-love.

Here are a few of my best tips on how to start this radical change in your *being*.

1. Be willing to be uncomfortable. I remember when I was a new therapist—I had an absolute *need* to make sure all my clients ended up with a nice little bow tied around each of their sessions. Everyone had to be happy and feeling good when they walked out of my office, or I wasn't satisfied. I felt guilty or too uncomfortable if things were left undone, or if there were negative emotions. The problem was that, when you deal with fighting couples, you run into both of those things a lot! It's funny to me today that I was a therapist with these specific patterns, but that's where I was at the time. I was afraid if they didn't feel good at the end, they'd leave, and remember, my upbringing was to "fix" everyone and make everything right, so this was hard for me. Thankfully, I don't struggle with that today, as I'm able to stand in the fire with and for my clients, holding all the feelings that emerge.

All these years later, I know that if you are desiring any significant change, you MUST be willing to be uncomfortable. I often tell my clients that, "I don't care if you are comfortable. I only care if you

are willing." It's kinda like childbirth, actually. You'll get something magical in the end, but it won't be without pain.

One of the stories I've heard that depicts this so well is from Michael Beckwith's book, **Spiritual Liberation**. He explains how, if you try to open an egg with a baby bird in it, the bird will die.

Turns out the very action of the bird pecking through the egg strengthens its beak such that it can then live outside of the egg. So, the seemingly difficult situation of having to peck through the egg is nature's way of ensuring survival.

Just like those baby birds, we humans also go through difficulties to get to the next level.

2. Tap into the pain your clients are feeling. Years ago, I was working with a man who was a psychologist in a pretty difficult niche. In addition to a regular practice, he specialized in helping people who had been abducted by aliens/UFO's. (You may not believe it for yourself, but there are lots of folks who claim to have had this experience and have loads of trauma around it.) Now, this particular man also lived in a very conservative southern state, so he tried to hide the work he did. Even though there's somewhat of an "underground" network of folks who assist people who have experienced this phenomenon, my client was terrified that he'd be judged by the people in his small town. He was very torn — having had his own experience with alien abduction, he understood the pain, trauma, and isolation the victims experience. In fact, many are suicidal. But in spite of this awareness (both professionally and

personally), he pushed back on every suggestion I made. His fear was paralyzing him.

One day, I said, "Look, there are people out there very likely feeling like they are going crazy because of what they have gone through. YOU can help them. Are you willing to walk through your own discomfort so they no longer have to suffer?" This turned out to be a transcendent moment in his life, because *once he was able to get out of his own fear and tap into the pain of his people and his deep desire to help them, everything changed for him.*

I have used this same method with many others, and I hope you'll try it for yourself.

Imagine someone suffering. She may have no hope. She may be in despair or making terrible choices. Can you move out of your fear and "little self," and tap into the big vision you have for that person? THAT is the highest form of loving your clients!

EXERCISE: Moving out of Fear

Sit quietly and allow an image of a client (or prospective client) who is in HUGE need to come to you. This person is suffering. She has lost hope. She is in despair and making terrible choices. Can you see her? How do you feel in your heart when you tap into the problem this person has that you could likely solve? Close your eyes, and really tap into that feeling.

Now, think about reaching out to her. Imagine yourself having an enrolling conversation to bring her into your business. Can you move out of your fear and "little self," and tap into the big vision you have for this person? THAT is the highest form of loving your clients!

Here's the thing: When it's about us, it feels transactional, and we get triggered. "Who am I to do this work?" and "How can I charge for this?" are two common self-statements people often hear when they are focused only on themselves and their fears.

But if you go outside of yourself and focus on someone else, then you can see that perhaps it is your soul calling you.

Remember, EVERYTHING in your life led you here, to this exact moment. All your experiences, good and bad, have put you in a position to be of the highest service!

3. Partner with the Divine. Or God. Or Life. Or Nature. Or Love. Whatever you call it, if you connect with the energy that is the Source of creation, what is there to be afraid of?

This is where being a love-based, mission-driven business owner comes into play.

Let me tell you this: If you are trying to run a business that is just for revenue, it will be a harder path. Instead, ask the Divine to show you what is yours to do. Ask to be guided. Tune in to a Higher

Power, so you can see the huge difference you make in the lives of those around you!

Trust me. If it's just about you and your little corner of the world, making money, it won't have the same richness as if you understand that YOU are chosen for a very special purpose. If you can stay tapped into the "why" of your work and the way you help people, you will have an easier time transcending.

Chapter 10
STEPPING INTO YOUR NEW LOVE-BASED IDENTITY

So far, we've talked about the patterns that keep you stuck in your "old" identity, and the importance of moving out of it if you're truly ready to be a love-based business owner.

Now, let's work some more on co-creating that new identity!

Remember, the goal of this book is to support you in embracing your new identity as a love-based business owner. That means blending the practical with the spiritual/soulful.

To be both the head and heart. To focus on people, and profit.

To have a business and a life *that works for you.*

This work is "identity" work. We focus more on your BEING than on what you are actually doing!

So, let's start by defining yourself as a business owner.

How do you see yourself?

I know this can be a hard question, because truthfully, people don't often examine their own leadership. They are so busy doing the business of running a business that they fail to pause and take

notice of the places where they may or may not embody some of these love-based principles.

To help you answer this question, complete the following exercise.

EXERCISE: Stepping into the BEING of a Love-Based Entrepreneur

Rate each of the following characteristics with a 1, 2, 3, 4, or 5 using the scale below.

- 💜 1 = Not really.

- 💜 3 = Mostly.

- 💜 5 = Yes, very much so.

1. I am wise and follow my truth.

2. I have a good sense of judgment.

3. I am very grounded and practical.

4. I have a strong sense of self.

5. I embody and honor a personal code that guides my decisions and actions.

6. I have a very strong sense of self.

7. I exercise positive habits.

8. I am a fast implementer.

9. I know how to make very solid decisions for myself and my business.

10. I reach out for, and get, support when needed.

11. I respect money and charge what I'm worth.

12. I understand what it takes to run my business.

Ok, you have a possible score of 60. What is yours?

If you scored lower than you'd like, no worries. Keep reading for more ways to step more fully into your BEING as a love-based entrepreneur.

But first, choose the three lowest scoring statements, and commit to working on them.

Like I said … when you have awareness, you have a choice.

So, become aware of the opportunity to grow here, and then you can take some new actions!

Speaking of actions, right about now, you may be wondering how in the world to integrate your love-based "being" into the business world.

How can you lead with love instead of fear?

Well, we start with what you do, how you plan, and how you decide what gets worked on.

Generally, when you decide on a strategy, you use a linear, left-brain, sequential method for making the decision. It's based on your goals, values, revenue plan, and bandwidth. Right? That's logical—the way we've all been taught.

But what if our brain isn't the best source of information all the time?

The human brain is actually wired to protect us by instilling fear! It will always show you what could go wrong or how things will fall apart. Seriously. It's a biological imperative from back in the caveman days. See, back then, things could jump out and eat you, so your brain became adept at predicting danger. These days though, there aren't hairy beasts hiding in caves. But the part of your brain that was wired to protect you can't distinguish between the scary hairy beast and the new speaking opportunity or program you want to create. Both conjure all kinds of self-talk, as your brain tries to keep you "safe."

As I always tell my clients, your brain is not your friend. Our brain is what gets things set up. But oftentimes, we first access information from other sources.

The problem is, even the best ideas we get from well-meaning friends and/or mentors may not be right for us. (Remember, so many people get seduced into following someone else's "fastest-path-to-cash formula." Sure, it might have worked for the guru selling it, but it may never work for you.)

Ok, "woo-woo" alert … but just open your mind for a moment and go with it, okay?

What if there was another way to get ideas for your business? What if you could source your information, and your next steps from a different place … a more reliable place than from outside sources or brain?

What if your soul or intuition guided you? What if *it* was the authority on what to do, what order to do it in, and how to go about it?

You *are* tapped into something greater than yourself. So why would you not be able to access that level of Guidance?

Try this on for size:

Your business has a soul.

The hypothesis here is that *everything is energy.* And your business is an extension and expression of you, and you have a soul. Thus, your business has a soul.

The work I do with my clients is to help guide them into "right relationship" with this source of connection, information, and inspiration.

EXERCISE: Getting in Touch with Guidance

Following is one of the most powerful exercises you can do to get in touch with Guidance.

It's a visioning process, made popular by the Rev. Dr. Michael Beckwith.

When you vision, you "catch" what the soul is trying to share with you.

The difference between visioning and what we typically get in visualization is that when you visualize, you actually conjure. You've likely heard those relaxation audios that ask you to imagine being on a beach, feeling the sun on your back or your toes in the sand, hearing the waves crash, and smelling the ocean water. You allow your mind to create based on what you already know. That's visualization.

But a visioning process is different. It's literally opening up and allowing for something new to be revealed.

100

So, are you ready?

EXERCISE: Visioning

Note: I've made an audio of this exercise for you, because it's often easier to relax and let someone guide you through it. It's called the *"Connecting with the Soul of Your Business"* meditation. I've also created a complementary worksheet for you to record your answers. Get them both in the Resources section below.

Part 1:

First, get into a comfortable position. Sit in a quiet place where you'll have 10-15 minutes of uninterrupted time. I'd suggest that you bring a journal to write down the information you receive (or download the accompanying worksheet).

Imagine the "soul" of your business is in front of you, and you can access it. You may see a literal form. You may sense the energy of the soul of your business. Either way, set the intention that *you will receive the information that will be right for you.*

Ok, now, you're going to connect with it to get some answers.

Ask the soul of your business the following:

"Please show me what's next for me and my business."

Now, here's what may happen:

1. You could get a very vivid picture.

2. You may "hear" in your head what the next chapter is.

3. You just feel or sense it.

4. You may get nothing.

DON'T try to analyze it or figure it out.

I find that most of my clients get stuck when their brain kicks into gear after they get the picture/sense of what's next. They tend to immediately get hit with the dreaded voice of self-doubt that tells them *there's no way they can even do this.*

Alrighty, so here's what I want you to do next, to make sure you don't get stuck:

Write it down. Whatever answer you received, you now know something about your next level. So, describe it in as little or as much detail as you need in order to remember it moving forward.

By the way, if you get nothing, don't stress about it! Sometimes it comes later. You'll notice a new idea float in or be drawn to something. If you didn't see or feel the soul of your biz, you can still keep going, because you may get more answers with the following questions.

Now, thank the soul of your business for showing you what it did.

Next, ask the following questions, one at a time, pausing in between to wait for the answers.

1. Who do I need to be in order to allow this in my life/biz?

Record whatever info you get, without judging or analyzing it. You are looking for the qualities and ways of being that will match that next level vision.

2. What do I need to release or let go of in order to grow?

Same process—write down the answer you receive without any attachment to whether it's "right" or "wrong," or with any strategy on your part. You may be asked to let go of people, old beliefs, bad habits, etc. Remember … no judging or fighting this part! Just ask and record.

Thank the soul of your business for this information, and ask the next question:

3. Is there anything else I need to know right now?

Write down what you receive.

Thank it again.

Please know if you didn't get the clarity you wanted to while completing this exercise, it's okay! Be patient. It may come to you later. You can also circle back and complete the exercise again whenever you'd like. (You may also want to ask yourself if there's any part of you that might be blocking the information, and if that's the case, ask it to go!)

My hope is that you now have the bigger picture of the strategy or project that is up next for you.

And that brings us to part two of this exercise.

Part 2:

The next part of this visioning exercise is designed to call forth the exact people you are here to serve—also known as your "ideal" or "soul" clients.

Imagine yourself in a place where your new clients will be. It could be in a huge stadium, a theater, an intimate venue, or any place where you are on stage in front of your people.

Notice them walking in and taking their seats eagerly with anticipation. From the stage, you look into their eyes and try to connect with their hearts. *These* are the people with whom you have a soul agreement! All you have gone through and all you offer have combined to create the perfect solution for whatever they need right now.

Now, I want you to tell them what you want for them. Explain what is in your heart in terms of your promise and ability to make a difference to them.

Next, ask them what they need from you. Ask them what words they want to hear in marketing messages that will light them up. Have them share what they are hoping to get from your work, and how you can best find and reach them. (Note: This is now allowing you to move into more grounded, tangible actions in terms of how you'll speak about your work, where to find your ideal clients, what words to use, or even how much to charge, etc. You can literally just ask these imaginary people for the answers.)

The final piece of this exercise is to invite them to move closer to you. Ask the ones who are ready for your work to come forward. You can energetically pull them in and make the connection.

Now, once you have done this, bring your imagery to a close.

You'll want to review your notes and write down as much as you can while it's all still fresh in your mind.

Remember, the initial inquiry you made of the soul of your business resulted in a brain dump, of sorts, right? Lots of ideas, but no form.

Now, you're equipped to create the form around it. You can build the programs or lay down the strategy.

What my clients love about this work is that, once they connect with the soul of their business and invite the clients to come closer, when they are ready, they simply ask their intuition to show them what's next.

That's right! Just ask! You'll be shown who to call or reach out to. You'll be shown what words to use and where to use them.

Which means, instead of just following the latest marketing trend or hot guru's guidance, my clients learn how to source the information from the right place. And then they can use the more logical part of their brain to figure out action steps.

This is what it means to be an intuition-guided business owner.

Chapter 11
TIPS FOR STAYING ON THE LOVE-BASED PATH

Just like anything else, when you're creating change, it's easy to periodically get derailed. Here are some of my tips for making sure you stay on the path toward your love-based destination.

1. Recommit daily. Trust me, there will be days when the old patterns show back up, and you'll wonder what the heck happened to the you who was wanting to bring more love into your business. We all have them! In the next chapter, I'll give you even more tips for staying the course, but if you can remember that you are forging a new identity and not just doing more "stuff" for your business, that helps. This could mean that every morning you get up and say an affirmative statement, visualize yourself being the new version of you, and put your focus on the future you want.

2. Acknowledge the changes. Here's something that will really help: *"Whatever you judge, you stick to you."* That means that if you are in the habit of judging how lazy you are, you are going to see more and more examples of your couch potato-ness! One of the tools I use with my clients is to have them decide which attribute they want to strengthen, and then look for evidence of it.

I would suggest that every night in your journal, you record any instance in which you move from fear to love in your decision making. Doing this regularly will begin to "train your brain" to look for more of what you want to see. This will strengthen the identity of the you that you are looking to anchor for yourself.

107

Remember earlier when we talked about picking just three things to start focusing on? You could do so by creating weekly or even monthly themes. For example, imagine you want to be more able to trust your intuition in your decision-making process. First, I'd ask you to map out what it looks like, feels like, and shows up as when you are in your desired state. Then, you'll want to note it every day.

EXERCISE: Acknowledgment Journal

I use this one with my clients a lot.

Different from a gratitude journal, this one focuses on strengthening the new qualities you create in yourself by acknowledging them. Here, you could reflect on your day by acknowledging all the ways your intuition was more prominent than normal. Rank yourself from low to high, 1-10.

What happens is that the more you focus on the place you have done the new behavior, the more it gets strengthened and becomes automatic. (By the way ... continue with your gratitude journal, too, if you wish! While it generates a wonderful state of being, the acknowledgment journal is a way of forcing you to track and measure what you desire to see more of.)

3. Talk and decide from the future you. This is where you really need to police your language. It's also a great idea to engage your friends or mentors to help you in catching yourself using the old language that is a reflection of where you are coming from now.

Talking from the future means speaking in present tense that which you want to see.

Here's an example:

"I feel so amazing that I have transformed my business in such a positive way. Instead of letting fear rule how I marketed, today I listened to my own guidance, trusted the information I got, and then took the right new actions. I'm feeling far more peaceful, and the clients I work with are loving the new way we are interacting."

In addition to "speaking the future into the now," you'll also want to use this sense of future you as the platform of your decisions.

It's easy to decide things based on what you know has worked or not. The problem is, if you keep deciding from the same place, you'll likely get the same results.

I remember when I wanted to engage the services of a mentor. Initially, my first thought was that I didn't really have the money, so my instinct was to wait. But when I asked a better question of myself, I got the right answer. I asked myself that if I was making the money that I knew I was able to make, would I then make the investment? I put myself in the future that I wanted to bring and decided from that vantage point. By the way ... that decision was a great one, and whenever I use this process, the decisions flow much easier and get better results.

4. Stay connected to your big mission/vision. Do you remember when we talked about the fact that there are people who are praying for you? People for whom you are their best solution to the problem they have … who you can help make changes, so they get what they desire? Please realize that the more open you are, the more you let love in and the less you dance with fear, the better you will be in service of these people. You can do daily visualizations of you being on that stage delivering your heart-felt message to them. The more you do it, the easier it is to embody.

Remember, your unconscious doesn't know the difference between imagination and real work. So, keep seeing yourself connecting and communicating with your people, and soon, you'll start seeing real-world results!

Chapter 12
AVOIDING THE LANDMINES

Sometimes, business takes off as if by magic. You decide on the love-based path, you start to leave your small space and put yourself out there, and it all just starts to flow.

Other times, your business will go so painfully slow, it becomes a test of your character. And that's likely when those old fears will kick back in. You'll be tempted to go back to the old patterns, but this, my beautiful business owner, is where the rubber meets the road!

These are the "make-it-or-break-it" moments for entrepreneurs.

After all, you have planted the seeds. You have shown up, decided to make the pivot in your business, when boom ... that little, annoying voice of fear kicks in. Or, you still haven't seen results for all the love-based action you're taking.

So, then what? What happens if you find yourself here, again?

My advice: Start evaluating yourself not on what you are doing, but rather, who you are BEing.

After working with loads and loads of business owners, I can tell you that this one thing can mean all the difference between having a business you love and one that absolutely drives you nuts!

I have just two words of advice for you, if you've found yourself in this place:

Stop collapsing.

THIS is what I specialize in with my clients.

Let me explain.

As human beings, we tend to allow the mind to run wild. We indulge in fear-based thoughts, which often leads to negative thinking.

You know the thoughts I'm talking about here … like, "What if it doesn't work?" or, "How come the results don't show up for me like they do for others?"

When you don't get the results you want, it is SO easy to let your mind go wild in reaction to those fear-based feelings. You might even want to scrap the whole project and start over!

Remember what I said earlier about your brain not being your friend? It's number one job is to show you all the places you could be at risk, how things could go wrong, and what to look out for to avoid danger. While that was great in the caveman days, in these days, when so much of what you do and the results you get depend on being in the right energy and alignment, this brain pattern can truly muck things up!

The key here is to learn how to deal with those fear-based thoughts in a way that keeps you from inadvertently empowering them to run you off track.

And this process takes work, trust me! It's not a natural skill, because again, your biology (the way your brain is wired) is *going* to fight you.

Let's look to nature to illustrate this point.

Imagine you're a farmer. You find the land, carefully clear it, till and cultivate the soil, research the best crop choice for the elements, and choose the nutrients and conditions in which to grow it. Then, it's finally time for planting!

What you KNOW: It takes a certain amount of gestation time. You don't expect to wake up the next morning to a six-foot stalk of corn! You also know that within the seed is the potentiality of corn. You don't have to worry about planting corn and sprouting up a watermelon.

The corn seed knows EXACTLY what to do. It knows how to release itself to the earth and also how to pull in everything it needs to become what it's meant to be. This is its Divine Design.

Now, imagine what would happen if you came back to the field every single day to dig up the seed just to make sure it was still there.

Imagine if, one day, you decide you want tomatoes instead of corn. Two days later, you decide zucchini is a better choice. Maybe you rush to find a new field to throw something in the ground. What would happen if you kept tinkering and tinkering and tinkering? Do you think by the end of the season you'd have a lush crop? No way!

Because you didn't trust the natural process of life and creation.

Can you see the parallel here to your business?

Just like in the farming scenario, you research. You cultivate. You listen to the people you are here to serve and to your gut and decide what you want to "plant" (aka market).

Heck, maybe you launch the very thing you launched last year that got great results, but this time, not so much.

So it begins:

That crazy brain of yours starts doing its biologically wired job.

It tells you that what you're doing isn't working. At first, you're okay … but a few days later, you check your stats and shopping cart. What you see triggers your brain again. It tells you it's not *ever* going to work. You start noticing you feel anxious. A pit forms in that deep, dark place in your stomach. Your brain tells you you're a fraud. So, you start swimming in doubt and wondering what you will do to recover. It tells you that this whole "business thing" is a really stupid idea.

By this point, you're either going to shut down and go into collapse mode, or you'll move into frenetic action—trying something (anything!) to get a sale and some money in the door.

Before you know it, you've slid right into using fear-based tactics to GET that sale, because you now are based in fear-based thoughts and emotions.

Can you see the downward spiral here?

Do you relate to the tendency to let what initially looks like absence of proof that something is working (or going to work) take you out of your alignment?

THAT, my dear reader, is what a collapse looks like. Your brain kicks in, your feelings get activated and, in essence, you are hijacked by emotion that isn't designed to help you at all!

Let me share with you what typically creates the collapse we just talked about, as well as the fear-based thoughts that play into it, so you can make sure to be mindful of it.

> **1. Comparison.** Yikes! The dreaded, shame-based, beat-the-crap-out-of-yourself habit that so many business owners contend with. There you are, doing your work, when you notice on social media how fabulous other people's businesses seem to be doing. Suddenly, your gremlins come out to feast! I get it. It's natural to look around you to see how you measure up. And it's a thousand times more difficult to hold

on to yourself when you aren't faring as well as the rest of the pack. But here's the deal—we never compare "up." We almost always compare to diminish ourselves, instead of to remind ourselves of our blessings or worth. So, next time you set yourself up to fall into this trap, remind yourself that it may not be your "season." And the truth is, you likely don't know what is going on behind the scenes with the person you are comparing yourself to.

2. Fatigue. The Dalai Lama once said, *"Fatigue is the enemy of compassion."* I completely agree, and I'd add that it is also the enemy of self-compassion. You *have* to watch your energy. When I was an addiction therapist, one of the tools we used with our clients was to teach them that most relapses happen as a result of being H.A.L.T.: hungry, angry, lonely, or tired. You are far more likely to slip into bad or old/unconscious choices when feeling any of those.

This applies to your business, as well. It's nearly impossible to pivot against obstacles while staying strong enough to build a love-based business if you are exhausted. Plus, once you're in a state of exhaustion, you trigger that part of your brain that is "fight or flight" focused, and you're then at risk for slipping back into fear-based thoughts and tactics. So, watching your energy levels and making sure your emotions are in check is crucial in avoiding the collapse.

3. Weak Boundaries. Someone asks you to do something. You really don't want to, but feel guilty saying no. Or, you

already have a commitment that you signed up for a while back, but today, you wake up and realize it really doesn't serve you. Can you get out of it?

Can you tell the person who wants to "pick your brain" that no, he will actually need to pay you for your work?

I'll tell you right now that you won't stop committing to things that don't serve you or stop giving away your services for free as long as you ride that slippery slope of codependency!

You'll need to strengthen your boundaries as you grow in your new identity.

4. Overwhelm. Having too much on your plate can lead to old behaviors kicking back in. Trust me, transforming into your new BEing takes time. By falling back into old habits, like placing the needs of others before your own, or overcommitting (because of that pesky "need to prove it" pattern), you practically guarantee overwhelm—and THAT is the fastest way to slide back into your old or unconscious way of being which, of course, can lead to collapse.

5. Money problems. Nothing instigates fear-based behaviors like money! It's this area that tends to tap into the deepest core fears we all have. Who out there hasn't had the fleeting thought that you may end up a homeless dog lady sleeping under a bridge? For most, dealing with their money challenges brings up more fear and "pushing" behaviors, or bad decisions that

end up backfiring. I could write another whole book just on money (and Michele PW also has a Love-Based Money book, if you are interested, that you can get here:), but suffice it to say, this area is absolutely loaded with old-pattern landmines that so often lead to collapse.

EXERCISE: List Your Triggers

Now, the list I just provided is a short one, and there are plenty more areas that will inevitably lead to collapse!

Take a few minutes now to create your own list. What are *your* triggers?

Maybe it's whenever your kids are sick, or when your partner pulls on your time and energy. Or, maybe you revert to old patterns of trying to be a superhero who does everything on her own when money is tight.

If you map out your triggers for collapse, you'll be more able to identify those situations when they're happening, and course correct before collapse.

Chapter 13
TIPS AND TOOLS FOR STRENGTHENING YOUR LOVE-BASED ENTREPRENEUR IDENTITY

In the previous chapter, I outlined a few slippery spots to watch out for, so you don't end up collapsing right back into fear-based ways.

Now, let's go over some ways to strengthen your newly forming identity.

1. Trust the process. We know that human babies take nine months to grow in the womb. But did you know an elephant's gestation is 22 months? An opossum's is only 12-13 days! (How's that for some fun trivia?) My point here is that there is a universal understanding that *all* things take a certain amount of time, and that you cannot expect those time frames to be shorter just because you really want them to be.

Now when it comes to business, time frames can be all over the board. Mentors will generally tell you that it takes three years for a business to become profitable (and, generally speaking, this is true). Then, out of nowhere, you hear about some whiz-kid who built a six-figure biz in six months.

And that's exactly why it's easy to get seduced into the "If you build it, they will come," concept. It's easy to believe that you too will get paid boatloads of money, and that it will be easy … blah, blah, blah.

Like I mentioned earlier, the truth is that sometimes, things *will* go amazingly well.

Other times, despite your best efforts and no matter what you do, you will not see the results you are after.

This is why you need to surrender to the Divine Order that has bigger plans for you.

I remember a few years ago, I was launching what had been my favorite sales program. I loved that work! It fed my heart and soul and got great results for the students I worked with. I was super-excited to roll it out again.

I was in the middle of running a women's retreat when I launched it.

The retreat was one of the "highest highs" I'd experienced professionally. There was love, there was transformation, and I was BEing my best: using my gifts in a way that made my heart sing.

But the sales program wasn't making me happy.

It did NOT get the enrollment I envisioned and I was NOT making the money I wanted. I couldn't believe the disparity!

And that's when it happened: in one moment, I found myself dismissing the magic of the retreat, falling into the pit of despair caused by the stupid numbers on a page telling me that not enough

people were buying my program! (Trust me, there were loads and loads of fear-based thoughts dragging me down.)

To tell you the truth, I wasn't just heartbroken—I was pissed! I'm talkin' the kind of pissed that has you yelling at the Universe, screaming, *"WHY ISN'T THIS WORKING??????"*

And I did that!

But guess what?

I heard something back:

"It's not working because you are not supposed to be doing this work any longer. There is something else you are to be focusing on."

That was one of those "what the heck" moments, let me tell you! Here was a body of work I'd spent years preparing. I'd perfected the model and teaching design. It had helped tons of people, yet I was being asked to release it!

As I have said all throughout this book, *you must trust the process.* You must understand how, just like in nature, things grow, and things die. And since you often can't control it, you must check your beliefs, stop struggling and pushing against what is happening, and learn to allow for the new.

2. Understand that sometimes, things aren't _supposed_ to work. To build on number one above, as much as we don't want to believe it, there are often reasons for things "failing."

In my world, there is no such thing as failure. I tell my clients that nothing is ever wasted; everything can be used for growth. But when we don't get the sales we want, or our business isn't functioning the way we desire, it's easy to fall right into the feeling of failure that really ends up keeping you stuck.

So let me speak to that, now.

I had a client once who was just heartsick about her launch. She felt it had been a total failure, even though she'd done everything "right."

I asked her the same question my clients have come to expect from me:

"And how is that perfect?"

See, I believe that everything that happens TO us actually happens FOR us.

Everything we go through, every experience we have … they're ALL designed for our growth.

By asking this particular client that question, I was able to help her see that there WAS a REASON the results fell short of her expectations.

In her case, that reason was her. When we deconstructed the situation, we realized that while the components of her program were good, what was missing was how she was showing up. She was being challenged to step up and give more of herself as a leader. In the beginning, she didn't see the pattern she was in. With my help, she was able to see that she'd been holding back due to her experiencing mindset issues around being seen and allowing her group to experience the more powerful way she was wanting to BE. So, in the long run, that "failure" was actually an invitation to adapt her BEing when it came to her work and her people. Once she got past that, it was amazing how she transformed her business.

3. Focus on abundance. This is a tricky one, yes. It's also SO important.

You may have heard the following sayings before:

"What you think about, you bring about."

"What you resist, persists."

"You get to be right, every time."

So, you've planted the seeds already. Right? Then, it's time to wait.

That waiting also requires you to *stand firm in the truth you want to see.*

But remember, that pesky brain of yours is designed to point out the impending doom and danger on the other side of the wait.

Watch your thoughts, carefully! You cannot afford to allow them to go astray in this particular place, because you'll likely end up pulling back out of fear ... thereby repelling the very results you desire.

What to do instead? *Flip your thoughts to those of abundance.*

I remember when I was going through that bankruptcy back in 2010. Truly not having money was the most scary and painful time in my life, so I totally get how your brain can suck you in. Mine was telling me that I'd very likely become that homeless dog lady!

Yet, in the midst of the horror of my situation, one day I bought a *huge* pack of toilet paper. And in that moment, my brain shifted from, "OMG, I have no money ..." to "Wow, I have an ABUNDANCE of toilet paper! This is going to last me a long time."

I know, it's funny. But I'm telling you, when I stopped focusing on the fear, and finally could be present, noticing an abundance of something (anything!) ... *then* I was able to trust more, be calmer, and take more love-based actions.

I started looking around for other areas of abundance in my life.

And I noticed that while I didn't have much money, I was WEALTHY in relationships. I had dear and loyal friends who took care of me

and loved the heck out of me. I had an abundance of love and connection.

I then began to force myself to see surplus and abundance wherever I possibly could, to stop the incessant brain-based nagging that reminded me of my struggle.

I'd look out and be in awe of the greenery. I had an abundance of grass and trees and leaves!

I would go to restaurants and see people eating out and notice the abundance of money flowing.

Shifting my focus also shifted me out of fear and into more faith. *That* is the key.

(And yes, this takes practice—but it's SO worth it.)

4. Live from the identity you want to step into. Remember my story about operating from the identity of a multi-six-figure earner, even when I wasn't?

The trick is to "act as if."

When things aren't going as you want them to, it's hard to remember that you ARE still moving forward! Even when you have to take a few steps back, or when you find yourself going sideways for a bit, you *are* still growing.

So when you're not seeing the results you want (yet), start "acting as if."

EXERCISE: Acting as If

Yes, this is very "Law of Attraction-ish," but it's SO important, if you want to make the future you the now you.

Step 1: Write down what you will be/do/have in the future.

Next, imagine you already have it. Imagine yourself walking into a business meeting or networking group AS those things.

How do you show up? Do you carry yourself differently? Is your body standing a little taller, your shoulders back, as you make direct eye contact?

What do you notice in terms of self-talk? How are you engaging with people as this future version of yourself?

Describe yourself, on paper.

Step 2: Start showing up like that *today*.

Imagine now that you ARE that future you, and practice making decisions from that identity. Market from that space. Enroll clients from this new/future energy and see what happens! I'd venture to say that when you do, you'll soon watch your future-self meld

with your current self, and you'll not only get better results … your identity will change, too.

And *that* is what makes all the difference in the world!

5. Get support. I can't stress this enough.

There will be times when it's just impossible to remain unstoppable (and faith-full!) when you aren't seeing the results you want.

That's why it's imperative that you call in those positive people who can help you navigate through the pitfalls.

Now, what you *don't* want to do is surround yourself with dream stealers! Trust me, the gremlins in your mind will already be making it tough on you by insisting that a lack of results is EVIDENCE that what you're trying to do isn't going to work. The last thing you need is a family member, friend, or neighbor chiming in with that lovely suggestion to "Get a good job, with benefits!"

What serves you better is a friend or mentor who can affirm for you that you *are* on the right track. This is the person who truly believes in you, and he or she can make all the difference in the world.

When I work with my clients, I often take on that role, "holding them" during those difficult times. I remind them of their past successes, keep them aligned with their desires, and on track toward their goals with the brilliance they *are*. They text me when they forget and have permission to draw on my strength. They send

progress notes, when they remember, and actually lovingly call me "Mama T." I have taught them to ask themselves, "What would Mama T tell me right now?" when they need to "borrow" my faith and belief in them.

So, who do you have to fill that role? I know it may be a stretch to reach out and ask for that level of support, but it's imperative! It's truly an invaluable gift you can give to yourself just by asking for it.

(If you'd like more support, I'd love to have a conversation about how I could help you get to this new way of being and doing your business. When you head over to the Resource section at the end of this book, you will find a link to my calendar. Use it to book time for us to have a conversation.)

Chapter 14
WRAPPING UP

In closing, I want you to remember that if you were called to run your business in a love-based way, you *will* be supported, so you can make a huge difference to you and the people you serve!

It's my view that if it's yours to do, it's meant to be.

So, ask for the path to be shown. Call in the clients. Trust the process. Envision your new identity and how you show up. And ask for support.

Mostly, remember your mission! Remember that someone is praying for what you offer ... and it IS absolutely possible to make a profitable business out of your gifts.

I'll leave you with this, from one of my clients who said it best:

"I'm thinking, Therese, that for me it's not about being a 'conscious' love-based entrepreneur; it's about being ME. It's about me expressing myself in a way that gives me the most fulfillment. It's also about using ALL of me, which to me is one of the best feelings in the world. I can't remember who said this, but I want to die having been 'used all up.' I don't want any part of me to have remained unused. And so for me, my work is about being as much of me as I can be at any given time, and it's the main source of my transformation as it's the part of my life where I can be most wholly and wholesomely myself." - Gitte Lassen

That's my wish for you, dear reader … to live a life where you are fully, truly, self-expressed, BEing your very best you, and making your contribution to the world.

Peace and blessings.

RESOURCES

The following resources can be found at www.ThereseSkelly.com/missionbookresources:

"How Much Are You Being Influenced by the Need to Prove Yourself?" Checklist.

Sample Declaration Ideas and Printable

Fear Busting and Possibility Creating Tool

Visioning Audio

My Calendar (so you can book your no-obligation discovery session with me!)

Other books in the Love-Based Business Series

Love-Based Copywriting Method: The Philosophy Behind Writing Copy That Attracts, Inspires and Invites
(Volume 1 in the Love-Based Business Series)

By Michele PW

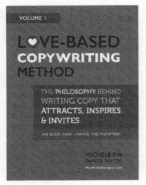

This book is a great place to learn more about the philosophy behind love-based copy and love-based selling. While it does include many exercises, it's more focused on the love-based philosophy and building a solid love-based foundation. If you're looking for a "how-to write love-based copy" book, definitely check out the next one in the series.

lovebasedpublishing.com/book/love-based-copywriting-method

Love-Based Copywriting System: A Step-by-Step Process to Master Writing Copy That Attracts, Inspires and Invites
(Volume 2 in the Love-Based Business Series)
By Michele PW

This is a copywriting course in book format. This "how to" book walks you through exactly how to write love-based copy. It includes exercises, copy templates and more. If you're planning on doing any sort of writing for your business—for instance, writing emails or website copy—this book is a must-have.

lovebasedpublishing.com/book/love-based-copywriting-system

Love-Based Online Marketing: Campaigns to Grow a Business You Love AND That Loves You Back (Volume 3 in the Love-Based Business Series)
By Michele PW

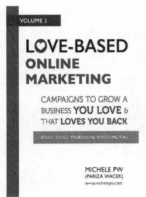

All successful, profitable businesses need a marketing plan, and this book walks you through how to create one that is perfect for you. You'll also learn the basics of selingl products and services online without feeling sales-y, and what might be standing in your way of successfully marketing your business.

lovebasedpublishing.com/book/love-based-online-marketing

Love-Based Money and Mindset: Make the Money You Desire Without Selling Your Soul
(Volume 4 in the Love-Based Business Series)
By Michele PW

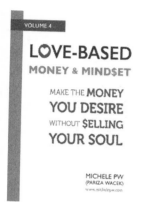

Are you ready to step into a life of peaceful prosperity? "Love-Based Money and Mindset" is designed to help you heal your relationship with money so you not only feel peaceful about it, but you're also able to attract all the abundance you want.

While this book is designed to help everyone who struggles with money issues, it's particularly helpful for those who have (or want to have) a business. The bottom line: the more you can cultivate a love-based mindset, the more easily and effortlessly you'll attract money into your life.

lovebasedpublishing.com/book/love-based-money-mindset

Love-Based Goals: Your Guide to Living Your Purpose & Passion
(Volume 5 in the Love-Based Business Series)
By Michele PW

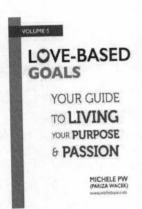

If you're ready to step into the life of your dreams and do it with ease and grace, this book can help. You'll get the tools you need to discover your love-based goals, get clear on what's stopping you and create an individualized plan to help you finally start living your dream life.

lovebasedpublishing.com/book/love-based-goals

Love-Based Business Models: A Simple System For Bulding A Business You Love
(Volume 6 in the Love-Based Business Series)
By Shawn Driscoll

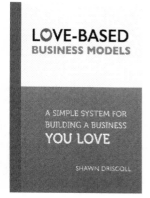

In this book, Business Coach Shawn Driscoll teaches you the philosophy and the foundational principles behind creating business models that fit with and support your life, priorities, interests, demands, strengths, and weaknesses. Whether you're a seasoned entrepreneur or you're just starting out, you'll discover practical tips and strategies for identifying and building a business around your unique strengths and your mission, using a model that maximizes your impact and supports everything that's important to you.

lovebasedpublishing.com/love-based-series/business-models

How to Start a Business You Love AND That Loves You Back: Get Clear on Your Purpose & Passion - Build a Successful, Profitable Business
Part of the Love-Based Business Series
By Michele PW

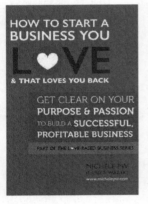

This book includes exercises and questions to ask yourself to make sure the heart of your business reflects what you really want it to. It's about answering the deeper questions around your business, like why you want it in the first place—because the clearer you are in your answers to those questions, the more satisfied you'll most likely be with what you eventually build.

Michele wrote this book for you if you don't have a business yet, but you want to get started, and you're intrigued by the idea of having a business you love and that loves you back.

Get it for FREE, here:

lovebasedpublishing.com/book/how-to-start-a-biz-you-love

About the Author
ABOUT THERESE SKELLY

Therese Skelly is a mentor and guide to women in business. In her former careers as a psychotherapist and a marketing consultant, she saw how often women sabotage themselves with their belief systems.

Today, her energy-based approach helps high-achieving women blast away those secret and destructive inner conflicts. Then, she helps them align the inner shifts with outer tactical, real-world strategies, so they're poised to step successfully into the work their souls are calling them to do to make a difference in the world.

When her clients learn to own their value, they thrive financially, spiritually, and mentally, while making more money in a business that makes them happy.

Therese's soul-driven yet practical approach makes her an in-demand virtual and in-person speaker at business conferences. She shares her home in Arizona with two lively dogs and is blessed to have two amazing sons who light up her life. *sexy boyfriend & the best soul-sister friends*

You can learn more about her here: www.thereseskelly.com.